# The Art and Science of
# BUTTERFLY
# PHOTOGRAPHY

**William Folsom**

AMHERST MEDIA, INC. ■ BUFFALO, NY

Copyright ©2000 by William B. Folsom
All photographs by William B. Folsom (unless otherwise noted)
Poetry courtesy of Victoria M. Medick with technical advice from W.T. Noel
All rights reserved.

Published by:
Amherst Media, Inc.
P.O. Box 586
Buffalo, N.Y. 14226
Fax: 716-874-4508
www.AmherstMediaInc.com

Publisher: Craig Alesse
Senior Editor/Project Manager: Michelle Perkins
Assistant Editor: Matthew A. Kreib

ISBN: 1-58428-019-0
Library of Congress Card Catalog Number: 99-76589

Printed in the United States of America.
10 9 8 7 6 5 4 3 2 1

Notice of Disclaimer: The information contained in this book is based on the author's experience and opinions. The author and publisher will not be held liable for the use or misuse of the information in this book.

# Index

## Chapter 5
## PHOTOGRAPHIC TIPS AND TECHNIQUES . . . . . . . . . . . . 66

## Chapter 6
## OVERCOMING PROBLEMS IN BUTTERFLY PHOTOGRAPHY . . . 81

## Chapter 7

# Preface

A new camera helped me discover a world of things I had never even seen before. The National Wildlife Federation Conservation Summits started me on the path to understanding wildlife photography. The National Wildlife Federation Conservation Summits are week-long environmental discovery programs to explore the natural history of a spectacular natural area and learn about conservation through a myriad of classes, workshops and field trips. I took courses in North Carolina, Nova Scotia, and Utah. I took my first course in butterflies at the 1984 Conservation Summit in Snowbird, Utah, under the direction of Dr. Robert Michael Pyle, a world-renowned lepidopterist and the author of *The Audubon Society Field Guide to North American Butterflies*. That afternoon, our class climbed through the alpine meadows of the Wasatch mountains and within moments Dr. Pyle found a Lilac-bordered Copper butterfly (*Lycaena nivalis*) feeding on an Indian paintbrush. Where moments before I had seen a pretty alpine field, I was suddenly aware of hundreds of delicate little creatures floating from one flower to another.

The butterfly sat patiently as each member of the class took turns photographing, and then fluttered off in search of nectar. When I got my slides back from the processing laboratories, I was stunned by the quality of "my" work. I never imagined that I could produce such an image. Indeed, it remains a favorite of mine and is shown in the final chapter of the book.

I've since gone on to photograph many species of butterflies and my collection numbers well over 500 images. I've also maintained close contacts with Dr. Pyle, who I consider both a mentor and a friend. I share his passion for butterflies (although I am barely able to identify most of the butterflies I have photographed) and I share my photographs with him for his educational programs. I am pleased and delighted to dedicate this book to Dr. Pyle for opening my eyes to the beauty of some of nature's most delicate creatures.

## ☐ Acknowledgements

I must first acknowledge the patience and assistance of my wife

"I was suddenly aware of hundreds of delicate little creatures..."

for serving as my helper while on the road. All too frequently she's had to wait patiently while I take one more photograph. Hopefully this will compensate for all those moments.

I would like to recognize the poetic skills of Victoria M. Medick who attended one of my classes. Ms. Medick wrote the introductory poem (below) specifically to illustrate the ultra-violet world of the butterfly in cooperation with her associate, W.T. Noel, a specialist in ultra-violet photography. I find her work beautiful.

Edward J. Pastula, of Reflective Imagery Ltd., read the first draft of the book and contributed his knowledge and know-how in the use of advanced camera equipment. He also took the photograph on how to hold a camera steady. Mr. Pastula shares my love of photography and his contribution is genuinely appreciated.

Dr. Robert Michael Pyle provided me his expert technical guidance and review of this book. Because of his willingness to share his love of butterflies and expertise with me, I now consider myself a better butterfly photographer.

Anneka Westall served as my technical editor. She is a gifted writer and trained in biological sciences. She spent years in the jungles of South America, where she observed some of the most beautiful butterflies in the world. She helped me craft readable prose out of what would have been some excruciatingly boring passages.

Thanks are due to the staff and volunteers at the National Wildlife Federation, Doris Rodriguez at Meadowlark Gardens at the Northern Virginia Regional Park Authority, in Vienna, Virginia, and to the staff at Brookside Gardens, in Wheaton, Maryland for allowing me to teach and to photograph at their facilities. Sherry Mitchell, author of *Creating Sanctuary* and *The Townhouse Gardner* allowed me to photograph her home and garden which is an oasis for wildlife in the midst of a major community.

Pat Durkin and the members of the Washington Area Butterfly Club also helped me find and identify butterflies. I respect their knowledge of butterflies and their willingness to share their knowledge. Richard Smith and Harry Pavulaan were especially helpful in reviewing the captions and photographs to make sure that the species of Eastern butterflies were properly identified.

## ☐ Technical Notes

All of the photographs in this book were taken using Nikon cameras and lenses and Kodak and Fuji professional films. I've used these products for over fifteen years and find that they meet my needs. There are a few other brand names of equipment or supplies that I have purchased and found helpful. I have also cited some places to visit, some useful web-sites, and a few books that I found instructive. Although cited, no endorsement of any manufacturer, company, association, product, service, facility, or web-site is implied or given. Omission of any name, manufacturer, company,

**BUTTERFLY SIGHT**

*A kaleidoscopic swirl*
*Slipping into another world*

*One which looked nothing as it had looked before.*
*Leaving behind the colors I had seen as real,*
*In its place revealed*
*Ultraviolet sight*
*Replacing visible light.*

*What I had known became unknown*
*So I could the unseen see,*
*Fractal images of high reflectivity,*
*Minute contrasts new incessantly*
*My attention drew*
*To brightness I never knew*
*Patterns emerged where only colors had been,*
*Insistently drawing me in.*

*Nature's power*
*Leading me to the heart of the flower.*

©Victoria M. Medick
Technical Advisor W.T. Noel

association, product, service, facility, or web-site neither implies nor connotes anything negative about their product or service. If you need current advice on any camera product, see your local camera dealer. I have learned to rely on the professional knowledge of the staff and managers at Penn Camera, Inc. at Tysons Corner, Virginia. See the appendix section for other sources of information.

This book was written primarily for photographers in North America, because that is where I live and photograph. However, the information offered in this book can be applied anywhere in the world. True, some adaptations may have to be made for local conditions (I've never photographed in a steamy jungle), but part of the fun of photography is learning how to do things. Much of what is written about photographing butterflies can be applied to many other insects or photographic subjects.

In reading this book, please take what I have to say with a grain of salt. I'm always discovering new lenses, films, cameras and ways of taking pictures. There are outstanding photographers who take extraordinary images of butterflies in completely different ways. If their techniques work for you, please use them. Better yet, invent your own techniques. But, no matter what, have fun and enjoy the beauty of nature.

"... part of the fun of photography is learning how to do things."

# Getting Started 1

"Some seven hundred species make their home in North America..."

The United States and Canada are two of the most exciting places in the world to study and photograph that most wondrous creature, the butterfly. Some seven hundred species make their home in North America, where they can be found from Florida's Everglades to Canada's Arctic. It is encouraging to find that more and more people are interested in learning how to capture butterflies on film. Helping them is the purpose of this book.

Butterfly photography is unique. Many butterflies are easy to find and photograph, while others are evasive or difficult to detect. To approach and successfully photograph these elusive creatures requires you to have special knowledge, equipment, film, techniques, and insight into butterfly behavior. This book is intended to provide that information.

Many beginning photographers rely on point-and-shoot cameras that produce fine photographs. Many of these cameras, however, are unable to take the close-ups needed to produce stunning photos, although newer models now come equipped with telescopic lenses that produce surprisingly good pictures. These relatively inexpensive, user-friendly cameras are perfectly acceptable for those who want to take good pictures without much fuss and bother.

Those photographers seeking to venture beyond point-and-shoot cameras need to develop an understanding of the fundamentals of photography. Craig Alesse's *Basic 35mm Photo Guide* (Amherst Media, Inc.) is a step-by-step, easy-to-understand book that teaches the principles of 35mm photography. Beginners are also urged to read as many other books on basic photography as possible, until a solid understanding of photography is established. The appendix lists reference books that provide detailed information on photography, including many topics not covered in this book.

## ☐ About the Butterfly

Butterflies are wonderful, harmless creatures that add beauty to fields and gardens, and are delightful to photograph. As the photographer

gains experience and confidence, images improve while knowledge of where to find butterflies increases.

Anyone interested in butterfly photography must first be able to locate butterflies. *The Audubon Society Field Guide to North American Butterflies* or the *Peterson Field Guides to Butterflies* should be a requirement, as these guides identify individual butterflies and provide information on where and when to look for a specific butterfly. These references also give the names of the butterfly's host plants and identify their geographic range. Much of this information is also available on the Wide World Web. One of the best sites to visit is maintained by the Northern Prairie Wildlife Research Center of the U.S. Geological Survey (see Appendix).

### *Moth or Butterfly?*

The differences between a moth and a butterfly are sometimes subtle. In general, moths fly at night, have feathered antennae, and rest with wings folded downward or out flat. Butterflies, on the other hand, tend to fly during the day, have knob-ended antennae, and usually rest with their wings folded upwards or above the body like a book. There are many exceptions, and a good reference guidebook is essential. For the most part, though, if it is fluttering about during the day and has knobbed antennae it is probably a butterfly, although there are many moths that are active in full sunlight, including the Hummingbird moth (*Hemaris thysbe*). Although most of the information this book relates to photographing butterflies, it can also be applied to other insects and more experienced photographers will no doubt enjoy the challenges of photographing night-flying moths.

Butterflies have existed for millions of years. The oldest known butterfly fossils are about fifty million years old. The ancient Greeks believed that butterflies were the souls of men; they called them *psyche*. At one time the Europeans called them "*butterflie*" or "*buterfleoge*" in the belief that witches in the shape of these insects stole butter and flew away. The current name is thought to have come from the name "butter-colored fly" after the Brimstone butterfly of Northern Europe.

Butterflies and moths both belong to the order Lepidoptera from the Greek "scaled" (lepis) and "wing" (pteron). Their wings are covered by tiny hairs and scales containing pigments that give them the extraordinary color or grooves which, when caught in just the right light, refract light to produce iridescent, metallic, or pearly colors. One must be quite careful not to handle a butterfly, which causes the scales to flake off and hinders its ability to fly.

### *Form and Function*

Like most insects, a butterfly's body is divided into three sections: head, thorax, and abdomen. The head has a pair of antennae, or "feelers," that are used to detect odors and locate food, and a proboscis for the actual feeding. Built like a straw and with heavily scaled sensory organs called labial palps on either side, the proboscis can be extended deep into a flower to suck up nectar, but it's kept curled up when not in use.

The thorax, or mid-body, has three parts (prothorax, mesothorax, and metathorax), each with a pair of legs. The mesothorax supports the two forewings, and the metathorax the two hindwings – all held in place by a framework of tubes similar to

> "The ancient Greeks believed that butterflies were the souls of men..."

### ☐ Moths vs. Butterflies
*In addition to the differences listed to the left, moths generally have a dull, brownish coloration, while butterflies generally have bright colors.*

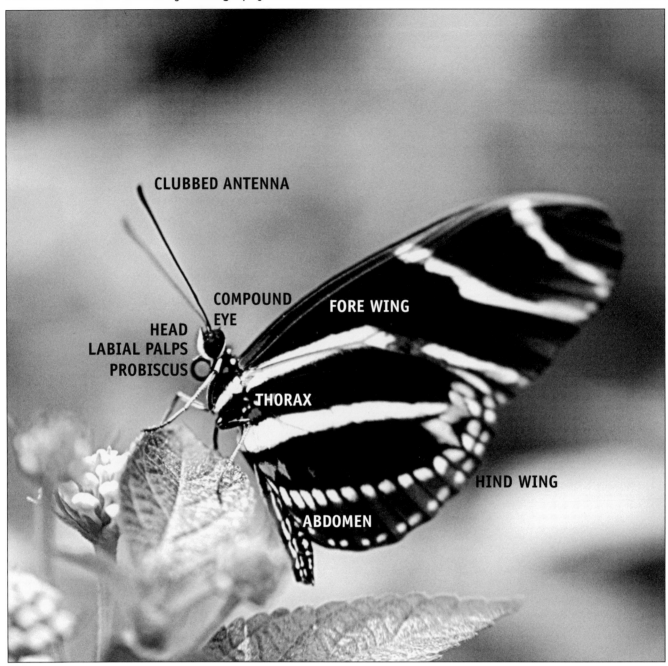

CLUBBED ANTENNA

COMPOUND
EYE

FORE WING

HEAD
LABIAL PALPS
PROBISCUS

THORAX

HIND WING

ABDOMEN

*Anatomy of the Zebra butterfly (Heficonius charithonius).*

veins. Upon emerging from the chrysalis, the butterfly must pump its body fluid into these "veins" in order for the wings to "harden" and permit flight. If the fluid fails to enter the wings, the butterfly will not complete its adult development.

## ☐ Butterfly Groups

There are two major groups of butterflies: true butterflies (*Papilionoidea*) which are usually slim with large, colorful wings, and Skippers (*Hesperioidea*), which are generally smaller, duller, and somewhat chunkier. Butterflies range in size from less than an inch (under 20mm) to those that exceed six inches (over 150mm).

### *Swallowtails and Parnassians (Papilionidae)*

Swallowtails are some of the brightest colored of all butterflies. Most are medium- to large-size and many have "tails" on the rear portion of the wings. The Giant Swallowtail has been measured at $6^{1}/_{4}$" (154mm).

The white, red-and-black spotted Parnassians, however, don't have tails. Males perch on hilltops or ridges, or patrol canyons, while looking for receptive females. After the female mates, she develops a hard abdominal pouch that prevents other males from mating with her.

### Whites and Sulphurs (Pieridae)

These are medium to small butterflies with white, yellow, or orange wings. The wings have hidden ultraviolet patterns used for identification during mating when the males patrol in search of mates. All visit flowers to sip nectar and most feed on legumes (pea family) or crucifers (mustard family). The Cabbage White was accidentally imported from Europe and their larvae are destructive to cabbage and related crops.

### Gossamer-wings (Lycaenidae)

The 100 North American members in this group include Blues, Coppers, Hairstreaks, and Harvesters. These butterflies are generally small. Many are brilliantly colored with iridescent blues, reds and oranges. Most feed on flowers and bird droppings. The caterpillar of the Harvester (*Feniseca tarquinus*) feeds exclusively upon wooly aphids.

### Metalmarks (Riodinanae)

The Metalmarks are small to medium-sized butterflies found mostly in tropical locations. Adults usually perch with wings open, and males rarely patrol. Metalmarks feed on nectar.

### Brush-foots (Nymphalidae)

Members of this family come in browns, oranges, yellows, and blacks. Brush-footed butterflies have small, hairy front legs, which is the reason for their family name. They often bask with their wings open at a 45° angle and fold them like a book over their body when feeding. Fritillary butterflies are part of this family. Most brush-foots feed on flowers, but some feed on sap, rotting fruit, dung, or the remains of dead animals.

### Tropical Longwings (Heliconiinae)

A sub-group of the Brush-foots, the longwings are some of the most beautiful tropical butterflies. Many species reach the American South, especially Florida. These include the Zebra, Julia, and Gulf Fritillary butterflies. Zebras are very social butterflies that gather together in the evenings, and are usually black with either yellow stripes or red and yellow stripes. The caterpillars of all species feed on passionflower vines.

### Milkweeds (Danainae)

The milkweeds are also brush-foots and include Queens and Monarchs, perhaps the best known of all North American butterflies. The Monarch migrates thousands of miles and overwinters in California and Mexico and is the subject of an international effort to save their last few refuges. The Queen is just as beautiful, but it remains in the southern United States. These large butterflies depend upon milkweeds to survive; the larvae feeding on these plants ingest substances that make them toxic to birds and other predators. The Viceroy looks like the Monarch and is avoided by predators because it might be distasteful.

### Satyrs and Wood Nymphs (Satyrinae)

Satyrs and Wood Nymphs dwell in woodlands and grasslands and are usually drab in color, mostly brown,

"... the longwings are some of the beautiful tropical butterflies."

helping them blend in with their surroundings. The caterpillars of this family usually feed on grasses and sedges, while adults usually feed on sap, animal droppings, and the sweet substance produced by aphids.

### Snout Butterflies (Libytheinae)

The American Snout (*Libytheana carinenta*) is the only snout butterfly found in North America; the snout is an elongation of the labial palps. The Snout Butterfly can be found on muddy soil or next to rivers or streams. The caterpillars of this family feed mostly on hackberry leaves.

### Skippers (Hesperiidae)

There are about 300 different North American species of skippers, and even lepidopterists have difficulty telling them apart. Skippers are short and squat with small, triangular wings that are generally bright tawny or drab. Some skippers resemble moths. There are three major families of skippers: spread-wing skippers (*Pyrgidae*); grass skippers (*Hesperiidae*), and giant skippers (*Megathymidae*).

Some populations of butterflies are thriving, but unfortunately others are slowly but quietly disappearing. Pesticides and herbicides aimed at controlling undesirable insects and weeds also poison butterflies and their offspring. Acid rain, global warming and other phenomena cause additional damage, but loss of fields, streams, and woodlands has a more ominous impact. Cities and suburbs sprawl into the dominion where butterflies once were abundant, and small farms give way to massive agricultural projects that displace even more of these fragile beings. If you are interested in butterfly conservation, see the Appendix.

"Pesticides and herbicides... also poison butterflies..."

# The Art of Photographing Butterflies

## 2

Many beginning photographers ask, "Where can I go to find butterflies?" It may sound like an odd question, but many people don't "see" butterflies until they learn to look for them. A professional associate illustrated this point. We were heading to the entrance of a historical site when I pointed out a bush swarming with yellow butterflies. "I never even saw them!" he exclaimed as we walked past. There were well over thirty butterflies feasting on this one plant.

### ☐ Where to Photograph Butterflies
#### *The Back Yard*
The best place in the world to photograph butterflies is often the back yard. Although there are more exotic species in tropical locales, the back yard offers the photographer unique advantages:

- One can plant flowers, shrubs, trees, grasses, herbs, or weeds that attract and sustain butterflies.

- The garden can be observed throughout the warm summer months. Within a few weeks, it will be possible to identify which plants attract butterflies and the best time of day to photograph them. By the end of the first summer, photographers can become quite proficient at spotting and photographing butterflies.

- A camera can be kept nearby, loaded with film and fresh batteries, and the photographer can usually find time for this art once the butterflies appear.

Conservationists encourage homeowners to dedicate a small portion of their garden just for butterflies. As more and more natural habitat is lost, it is important that butterflies have access to places that help fill in for those wild areas that once sustained their populations.

Most North American butterflies feed on nectar available from annuals already common to gardens or on plants readily available from garden centers or nurseries. A garden rich with flowers, herbs, grasses, and fruit-bearing bushes or trees will be a

"... many people don't 'see' butterflies until they learn to look for them."

15

*The Virginia home of Sherry Mitchell, author of 'Creating Sanctuary' and 'The Townhouse Gardner' is an oasis for wildlife amid the carefully manicured lawns of suburban homes.*

magnet for streams of butterflies throughout the warm months. For maximum benefit, the butterfly garden should be in a sunny location that is protected from winds and where butterflies can escape predators. Shrubs, tall grass, or log piles allow butterflies to roost safely at night, bask in the day, and seek shelter from wind or rain.

Taller flowers and bushes should be planted in the back and shorter ones in front and timed to allow blooms through the season. Clusters of plants keep butterflies moving from one clump to another without competition.

Some beginners think that because a butterfly is common in their neighborhood, it can't be of much value to photograph. But it's not a question of how common a species is, but rather how effectively one can photograph it. You should strive to take the best possible photographs of butterflies found in a specific region, including some of the least known species. Later, if you want to have your photographs published, you'll have a better chance of competing in a tough, crowded field because you will have carved a niche that others may have overlooked.

### Parks and Gardens

Photographers may not have the space, time, or green thumb needed for a lush garden. In that case, botanical gardens and public parks provide good spots for photography. Many parks have installed butterfly gardens featuring local species of flowers, shrubs, herbs, trees, or grasses. Public or botanical gardens sometimes offer an added bonus: identification of the host plant. This allows the photographer who wants to attract butterflies to a

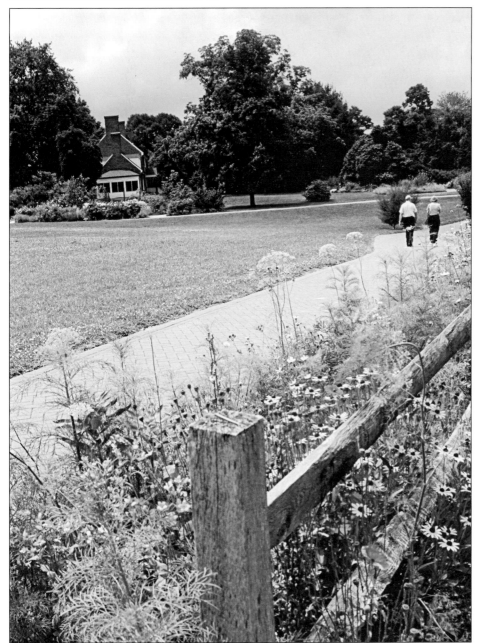

*The wildflower garden at Green Springs Gardens Park in Fairfax, Virginia features native plants that attract local butterflies.*

home garden to look for similar plants at the garden center. Having the proper name (including the Latin or scientific name) is also useful if an editor requires that information for a piece on butterflies.

Meadowlark Gardens in Northern Virginia is an example of a garden that's ideal for attracting butterflies. The facility features carefully planted formal gardens, an herb garden, a butterfly garden and two lakes. The herb and butterfly gardens, in particular, are covered with butterflies sip-ping nectar from fragrant flowers. There is a shaded area where hostas grow next to a small stream, as well as open meadows and a path lead-ing through woodlands. The garden is unique because it brings together many different habitats that attract a wealth of insects, birds, and wild animals.

### Butterfly Gardens
There is a growing trend in North America for garden clubs and con-servation groups to plant "butterfly gardens." Some plots involve only a

"... it brings together many different habitats..."

few plants; others are quite elaborate. Grade schools have also begun to plant nectar plants that attract butterflies and in some communities, gardening clubs have joined with butterfly or photography clubs to support conservation efforts and foster greater appreciation for butterflies.

### Butterfly Houses

The first butterfly conservatory built in the United States was Florida's "Butterfly World," north of Miami in Coconut Grove. Visitors enter the indoor aviary-like space to the accompaniment of harpsichord tunes by Mozart as hundreds of butterflies dance from blossom to bloom amid tropical plants. Photographers can test their skill at close-up shots, but are advised to finish up a roll before leaving home to make sure that the camera is oper-

ating properly. Fresh batteries and lots of film are strongly recommended!

There are many butterfly houses being built across the United States and overseas. These "houses" are enclosed buildings or aviary cages where butterflies fly freely and visitors stroll among the foliage. This is a marvelous experience and excellent photographic training. Most butterfly houses do not permit the use of tripods, but this isn't a major obstacle since tripods should not play a dominant role in butterfly photography – more about tripods later on. Web-site addresses of butterfly houses are listed in the appendix.

Some purists object to photographing captive butterflies, advocating photography in the wild. However,

*Below: A National Wildlife Federation Schoolyard Habitat (for birds and butterflies).*

*Opposite page: Butterfly World was the first butterfly park built in the United States. Visitors can stroll through the facility while hundreds of butterflies soar freely to classical music.*

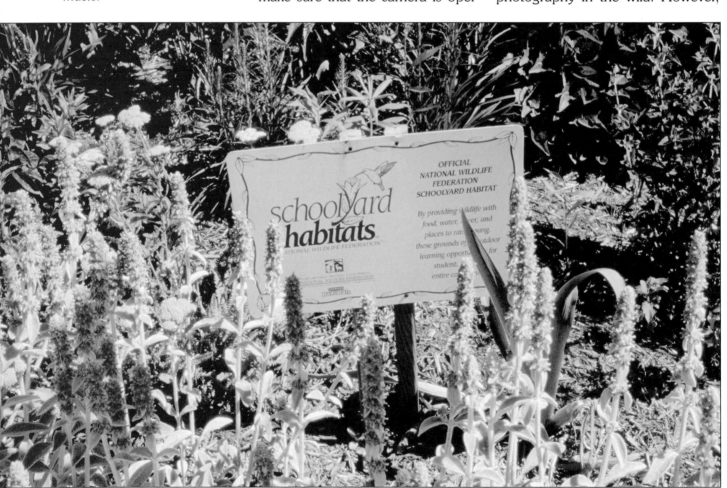

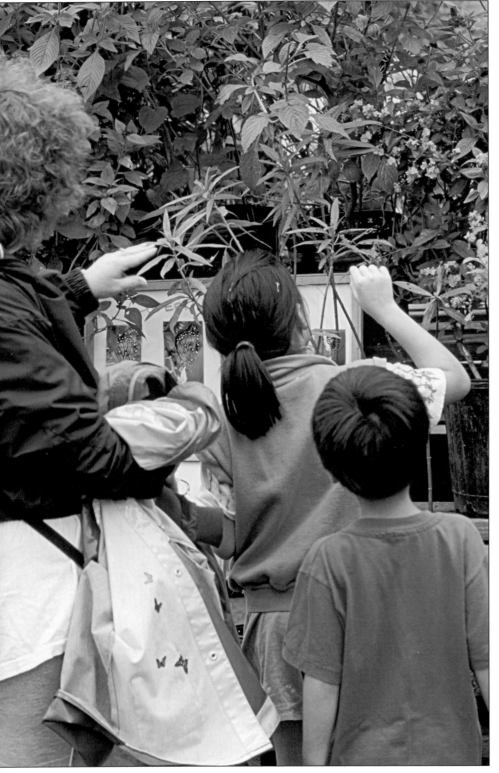

*Adults and children alike can learn by visiting a butterfly farm.*

an opportunity to photograph these species without stressing them. A great deal can be learned in such enclosed environments. Photographers are encouraged to use these facilities as classrooms.

### Butterfly Farms or Ranches

A number of butterfly farms or ranches have been established in the past few years that specialize in raising butterflies for sale to butterfly houses. "Butterflies in Flight" in Naples, Florida, for example, allows paying visitors the chance to see these insects being raised. The enterprise tours the United States each year, allowing thousands of children and their parents to see butterflies up close and this is an ideal opportunity to photograph butterflies – nearly every visitor enters the tent with a camera.

Other farms are found overseas, particularly in the tropics where ancient rainforests are threatened by the need for wood and arable land. Conservationists in some of these countries have shown villagers how to raise butterflies native to these forests for income greater than from forest products. In many remote parts of the world, raising butterflies for sale has helped slow the destruction of rainforests to the benefit of man and butterfly.

Many butterfly groups, including the Lepidopterists' Society, the North American Butterfly Association, and the Xerces Society, are strongly opposed to the release of farm-raised butterflies at social events. Dr. Robert Michael Pyle, one of America's foremost experts on butterflies, cites the possibility of genetic problems, spreading of diseases (especially among monarchs), and the confusion it can cause to butter-

because butterflies in conservatories are scrupulously fed and protected from predation and harsh weather, their wings are less ragged than those of wild butterflies. Also there are greater concentrations of butterflies (many of the showier species) in one area. Butterfly houses provide

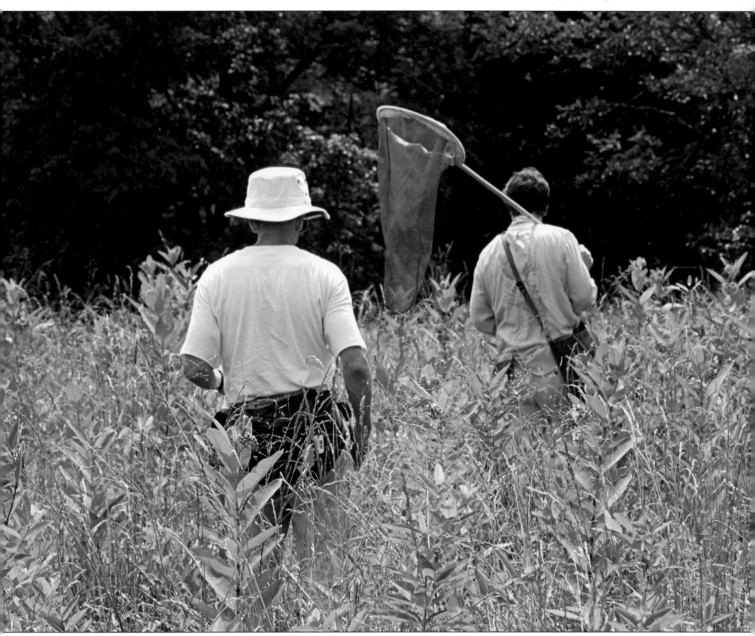

fly surveys and mapping and atlas projects, which are very important conservation events.

### In the Field
Butterflies don't frequent only gardens, but live along the seashore, in the mountains, deserts, prairies, meadows, and woodlands – in just about any locale from Florida to Canada. As one perfects photographic skills close to home, it's time to go farther afield. This is where it gets a lot harder to find and photograph these elusive creatures. Here it may be helpful to seek the companionship of others interested in butterflies – ten pairs of experienced eyes are better than one, and so it might be worth joining a local butterfly club and participating in their activities. The World Wide Web might be helpful in locating a butterfly club (see the appendix). Club members are generally adept at spotting butterflies and delighted to find new species to add to their collection. The club might also appreciate photographic images of field trips or unusual sightings for use in its newsletter.

*Volunteers count butterflies during the July 4th Butterfly Count in Virginia. Local butterfly clubs help expand the nation's knowledge of butterfly populations and welcome new members.*

flies than red ones. Obviously, butterflies can be found on flowers of many different hues, shapes, and sizes, but look for violet, blue, white or yellow field flowers, because they're more likely to attract these insects.

### Buffer Zones

Many different species of butterflies can be found in the buffer zone between two habitats. Right-of-ways under gas or electric power lines are within easy reach of the safety of the woods and thus attract both woodland and meadow species. The ground along a streambed meandering through these habitats provides an opportunity to see butterflies "puddling." Puddling is simply a gathering of butterflies. They may puddle near the edge of a stream where they drink, or they may have a spot where they gather to feed on salts or other minerals. If not sprayed, right-of-ways and logging or fire roads are all worth exploring because of the profusion of wildflowers growing here.

A word of caution about field work. It's a good idea to tuck the legs of your pants into your socks and apply a spray to ward off ticks, especially deer ticks. A careful search of exposed skin is also prudent after wandering through woods and meadows. Be alert for snakes too, which like to laze in the same morning sun that attracts the butterflies you want to photograph.

### On Business Trips

Business travel can be hectic and stressful, especially while rushing from one appointment to another. But it's often possible to find a half-hour in the morning or early evening to walk around the motel or hotel in

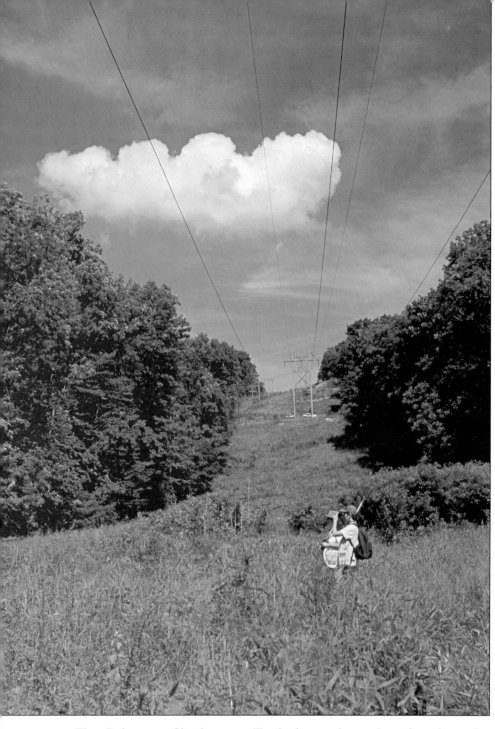

*The Baltimore Checkerspot (Euphydryas phaeton) is found in the marshy areas under a powerline in the Catoctin Mountains of Maryland.*

When in the field, it's important to remember that butterflies see both in the visible color spectrum and in the ultraviolet part of the spectrum which humans can't see. That is their world, and this affects their choice of host flowers. What humans see as a solid yellow flower may appear as variations of white and blue to a butterfly. Blue and violet flowers are more visible to butter-

search of bushes and flowers that attract butterflies. These pleasant forays may allow the photographer to add one or more species to a collection of images. It may not always be practical to visit local parks, or gardens, but foliage at or near the lodging frequently attract butterflies.

### On Vacation

The best time to photograph butterflies is when one can go into the field properly equipped. It's rare that butterflies can't be found at nearly every stop along the road, from a rest stop to a roadside picnic table to a state or national park – once attuned to looking for butterflies, it's easier to find them. Butterfly scouting is also an entertaining way to keep children occupied on long trips, although care should be taken against unsupervised exploring. Bring along a camera too while fishing or lying on the beach. Then, when the fish stop biting or the sun gets too hot, head out and look for butterflies. More than one photographer has become so fond of the pastime that family vacations are planned around the activity!

### In the Home or Studio

Amateurs and professionals alike can photograph butterflies in the house or studio. Finding caterpillars, and bringing them home to rear, is especially rewarding when the butterfly emerges from its chrysalis. Since the metamorphosis can occur within a few minutes, it takes careful observation and planning to capture the event on film.

The chrysalis usually changes to a darker color or becomes transparent shortly before the butterfly emerges. If the chrysalis was placed on a plant, the emerging butterfly will be situated in a natural surrounding. It

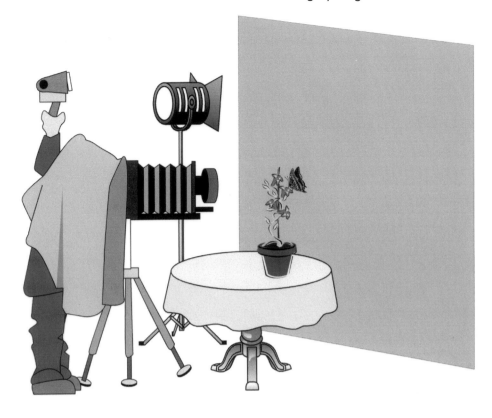

will then swallow air to help pump fluid into the veins of the wings before it can fly. That allows a little more time to take pictures.

The camera should be placed on a tripod within two to three feet of the subject. The view through the viewfinder should include enough space around the chrysalis to allow for the butterfly's emergence. For best results, the main flash unit should be placed to one side and connected to the camera. If available, a second flash, equipped with a slave unit that fires automatically once the main light goes off, should be placed on the other side for more even illumination. Otherwise, place the second flash behind the subject, out of sight of the camera, and aimed at the background paper for shadowless illumination. The background should be around five to six feet behind the subject yielding a softly blurred image. In most cases, it's a good idea to use various shades of green as the background.

### □ Purchasing Butterflies

*Butterfly farms on the Web can deliver live butterflies to their clients the next morning. Common butterflies are less expensive, while rare or exotic species can be quite expensive. The Web allows consumers to compare prices before ordering. The butterflies are usually shipped in a cooled container and can be set up on pre-existing props for maximum effectiveness. Photographers are strongly urged not to release these butterflies into the wild. After taking photographs it is best to place the butterflies in a freezer. Many leading authorities on butterflies, including the Lepidopterists' Society, the North American Butterfly Association, and the Xerces Society, are strongly opposed to the release of farm-raised butterflies into the wild.*

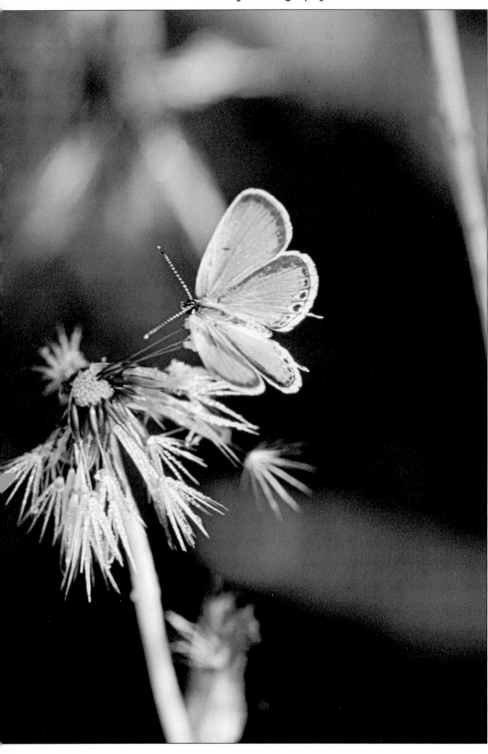

*A tiny Eastern Tailed-Blue (Everes comyntas) basks atop a dandelion in the early morning.*

emerges from the chrysalis. Many of the books listed in the appendix include information on raising butterflies that may be helpful for home or studio photography.

## ☐ When to Photograph Butterflies

Knowing when to photograph butterflies is almost as important as knowing where to look for them. The more you know about butterfly behavior, the easier it is to find them. In warmer climates, such as in the region around the Gulf of Mexico, New Mexico, Arizona, and southern California, butterflies can be found throughout the year. This is also true for Puerto Rico, the Virgin Islands, and Hawaii. In many other parts of North America, they begin to appear when winter freezes give way to warmer weather. Butterflies must wait until the sun warms their body before they can fly; most activity begins after eight o'clock in the morning. In warm tropical climates, butterflies may become active much earlier. The best time to find butterflies is on a clear, warm day (usually above 60° Fahrenheit or 16° Celsius) when winds are minimal and flowers are abundant; many species remain active well into the evening.

### *Basking*

Each morning when the grass is still wet with condensation, the early-rising photographer can take dazzling images of butterflies covered with dew. Butterflies cannot fly if their body temperature falls below 50°F (10°C ) or when they are drenched, so this is an opportune time for photographs. However, a frightened butterfly may drop to the ground, making it difficult to find and photograph. This is one of the times that a tripod can come in handy – provided it will reach low enough to the

Woodland butterflies should be photographed on bark with shades of brown in the background. Light blues also produce effective backdrops. Paper backgrounds can be bought at art supply or photo stores. It's worth taking a few test photographs to make sure that the image and background are properly illuminated before the butterfly

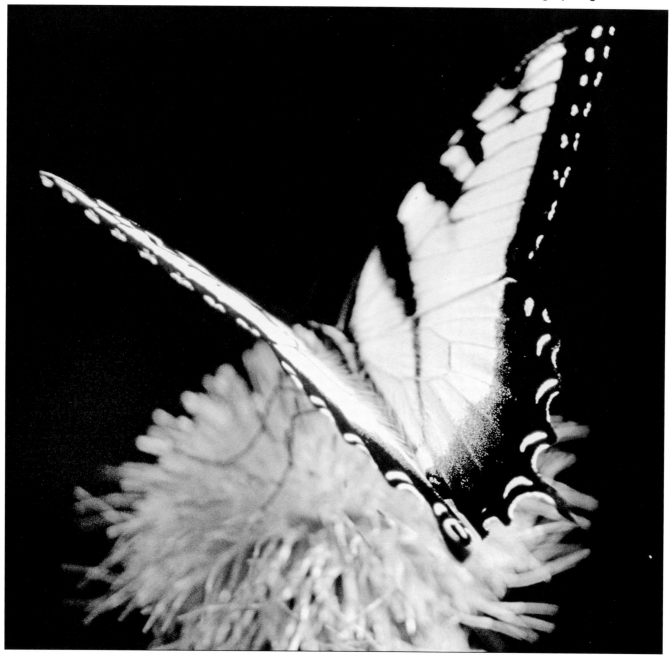

ground to shoot directly at some of those tiny butterflies clinging to a stalk of grass. If it doesn't, buy a sack of beans, a "bean bag" at your camera store, or fill a gallon plastic baggie with rice or beans. Place the camera on the beanbag and use that to keep the camera steady. Expect to get soaked while sprawled out on the ground, but this method should generate some interesting and unique photographs.

Butterflies bask with their wings open until the rays of the sun have warmed their body temperature to 75° to 85°F (24° to 29°C). Some bask with their wings closed and at right angles to the sun (lateral baskers), while others keep their wings open (dorsal baskers). Once warm, they begin their daily search for food or mates.

### Feeding
Butterflies feed as both caterpillars and mature butterflies. Caterpillars must consume large quantities of food (usually green vegetation) in order to undergo metamorphosis,

*An Eastern Tiger Swallowtail (Papilio glaucus) feeding on a thistle in a Virginia home garden set aside to attract wildlife.*

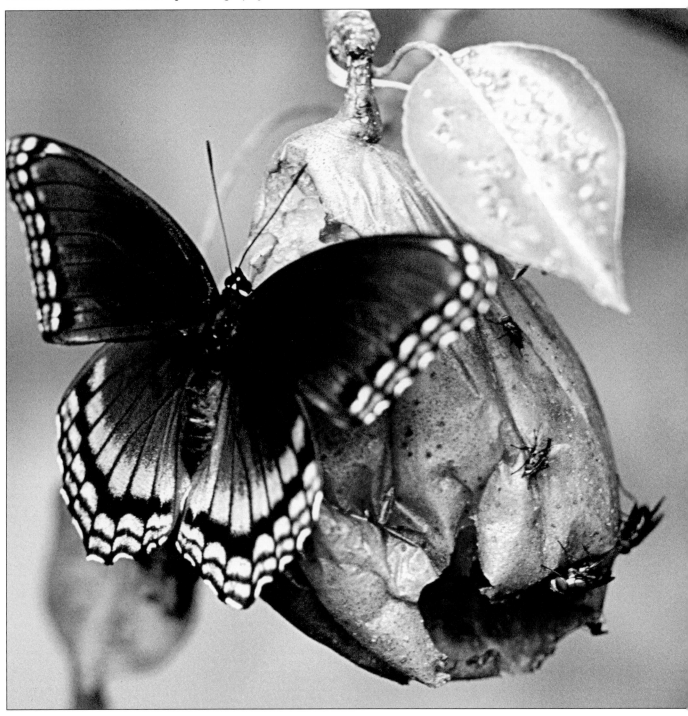

*A Red-spotted Purple (Limenitis arthemis astyanx) feeding on a rotting pear. Hundreds of butterflies are attracted to this particular tree every autumn.*

but many adult butterflies also need large quantities of food – usually high-energy sugars found in nectar, as well as various minerals, salts, and other organic foods during this intense period of their lifespan.

Knowledge of the sources of food needed by individual butterfly species allows an individual to find and photograph these creatures, confident that they will return over and over again for future photographic sessions.

• On Flowers
Flowers are the source of food most closely associated with butterflies, and most butterflies accept nectar from many flowering plants. A few species, however, only feed on a few species of flowers or plants (making these butterflies especially vulnerable to climate change, fire, herbicides,

pesticides or other things that eliminate their source of food).

Some of the garden variety flowers and plants most popular with butterflies are the aster, bee-balm, black-eyed Susan, borage, butterfly bush, butterfly weed, common zinnia, coreopsis, cosmo, daisy, daylily, flowering tobacco, French marigold, honeysuckle, goldenrod, Joe-Pye weed, lantana, lavender, liatris, mint, orange milkweed, pentas, petunia, phlox, pincushion flower, purple coneflower, rosemary, spike gayfeather, stonecrop, sunflower, and wax-leaf privet.   Other species, naturally, have their favorites.

• On Ripe Fruit
The ripening fruits of late summer and autumn attract a host of birds, animals, and insects, including butterflies. The juicy flesh of ripe pears especially attracts dozens of butterflies. Some people attract butterflies by placing outdoors ripe or rotting bananas, blueberries, cherries, figs, melon, oranges, peaches, or even slices of watermelon. Anglewings, Leafwings, Emperors, and Wood Nymphs seldom feed on flowers but are attracted to rotting fruit, placed in a shaded area. Many insects prefer rotting fruit because it is easier to extract the juices.

Unfortunately, fruit left outside also attracts ants, bees, flies, gnats, hornets, wasps, slugs or snails, and even birds, opossums, raccoons, or skunks. Placing fruit in an elevated, horizontal "bait station" can minimize butterflies' competitors.

• On Sap
Sap is sweet and nutritious and so will entice butterflies. Broken tree limbs or cuts on the trunk of the tree lure butterflies to feed, especially those that live in woodlands. This is a good place to look in the early spring, when many sap-feeders, such as Anglewings and Tortoiseshells, come out of hibernation. Woodpecker holes, especially those of sapsuckers, may also cause sap to drip.

• On Sugar Water
A mixture of one part sugar and eight or nine parts water placed on a single flower or sponge with an eye-dropper will sometimes keep a butterfly sipping this elixir long enough to take several photographs. But, it may also attract wasps and bees that could interfere with the butterflies or the photographer. This "bait" could be very helpful for someone using a telephoto lens to focus on a single flower. Wood nymphs, Admirals, and others also feed on the "honey-dew" produced by aphids found feeding on flowering plants.

Some companies have started to manufacture butterfly feeders that are similar to those used for hummingbirds. These feeders are designed specifically for butterflies and come with specially formulated nectars. But they don't provide an aesthetic setting for a photograph and some leading lepidopterists question their ability to attract butterflies.

Some lepidopterists seek out forest-dwelling members of the Nymphalidae family (such as Mourning Cloaks, Anglewings, or Satyrs) that rarely feed on flowers by setting out a bait mixture consisting of stale beer, diluted molasses, and brown sugar, but this too may attract other undesirable insects.

"This 'bait' could be very helpful for someone using a telephoto lens..."

27

• On Salts

Many male butterflies require sodium, a component of table salt, as part of their diet while mating. Males can be found puddling (gathering) around areas where salts are present in the ground. In that case, the butterflies will return to the same spot day after day, week after week and even year after year. It is possible to set up camera equipment and enjoy taking photograph after photograph – knowing that the butterflies will come and go throughout the day.

The butterflies most commonly found puddling include: Admirals; Angelwings; Blues; Fritillaries; Hackberrys; Satyrs; Skippers; Swallowtails; Sulphurs, and the Cabbage White.

• On Other Minerals and
Organic Material

Just as male butterflies need salt, they also need other minerals and organic materials. There are permanent locations where butterflies return to extract minerals from the earth. These are associated with wet sandy spots next to rivers or lakes, but other locations can also be found, such as along a road. Some sites, though, are temporary – rotting fungi, animal or bird droppings, urine, or the remains of dead animals. Whatever the source of the organic compounds that attract

*Eastern Tiger Swallowtails (Papilio glaucus) along a gravel driveway in South Carolina. Males need extra salts for the production of sperm.*

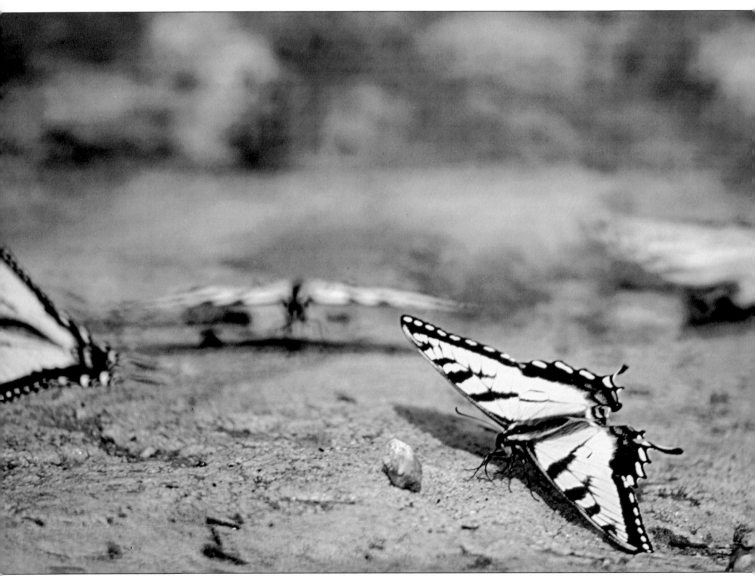

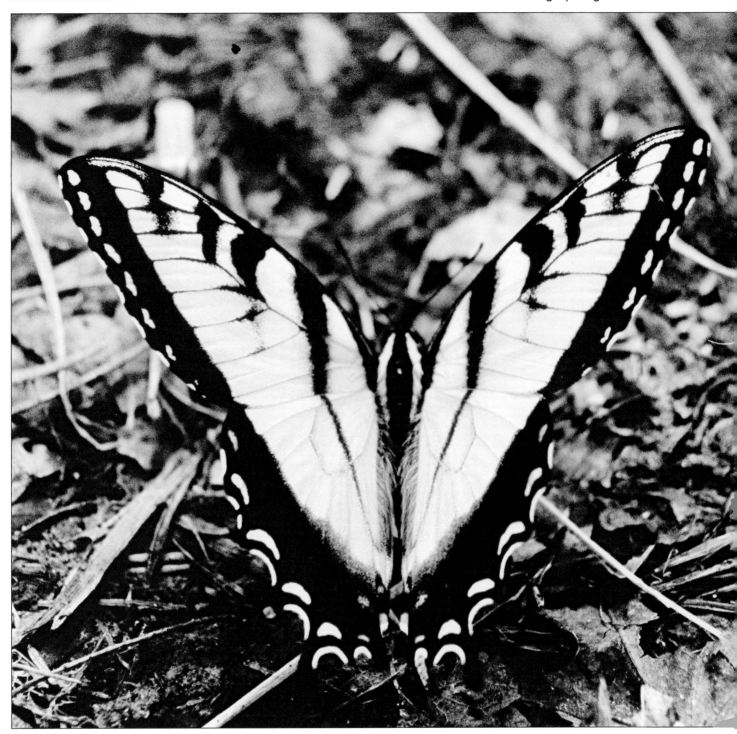

insects, butterflies seeking food will also be attracted. Scat and carrion may not be particularly attractive settings, but they can alert photographers to the presence of butterflies resting nearby in more photographic surroundings after feeding.

### Drinking

Most butterflies spend some of their day near mud puddles, brooks or streams, or along the shores of lakes. They may be soaking up water to help them dilute the salts they absorb, but sometimes it's hard to tell if they are drinking or absorbing the salts or minerals. It really doesn't matter, though, because it provides the photographer time to photograph them. And, in fact, the would-be photographer can capitalize on butterflies' thirst by filling a

*An Eastern Tiger Swallowtail (Papilio glaucus) feeding on the droppings of a small animal.*

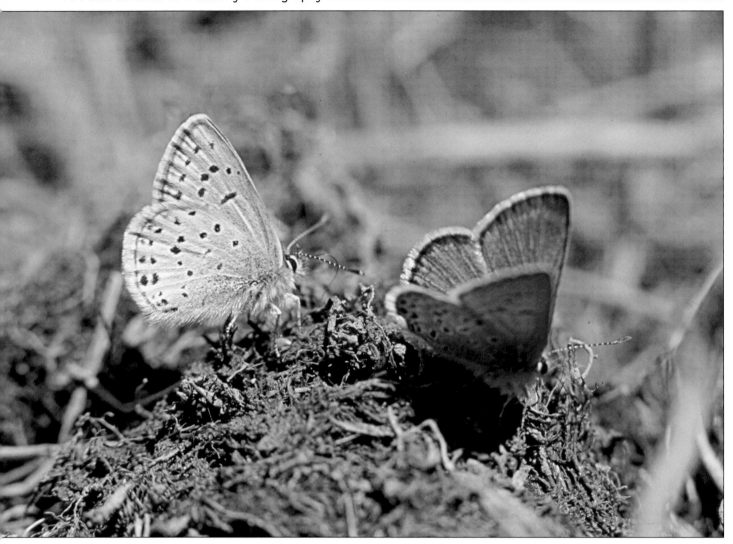

*These Greenish Blues (Plebejus saepiolus) were "puddling" near a stream feeding into Lake Panquitch in Utah. These tiny butterflies thrive in open meadows near European white clover.*

shallow pan with pebbles or sand and leaving it out overnight. Dew collects at the bottom of the pan that the butterflies can reach with their proboscis, while staying dry on the pebbles. The pan should be shallow enough to allow all the water to evaporate during the day to avoid mildew and it should be placed close to a tree or shrub should the butterfly need to hide from predators.

### Resting

After feeding, butterflies frequently appear to take time out for a rest. There are plenty of opportunities to photograph butterflies sitting quietly on a bush, branch, or rock. These same butterflies were perhaps fluttering around only moments before in search of nectar. They may now simply be conserving energy after a hearty meal, or they may be keeping an eye out for possible mates or intruding rivals. Whatever the reason, the observant photographer benefits.

### Perching

Male butterflies frequently perch on a favorite twig or branch where they can observe receptive females entering their territory. If the female is receptive, courtship usually follows, but if the female has already mated, then the male returns to his perch. The male also intercepts rivals and discourages them from remaining in his territory. Some species show signs of aggressively protecting their territory to the point where they may "attack" any intruder, including

birds (with possibly fatal consequences) or humans. Most return to their favorite perch after driving off an interloper. Once a butterfly perch is located, the photographer can repeatedly return to this site.

### Roosting

Butterflies seek a place to settle down to sleep at night. They roost under large leaves, on tree trunks, in a crevasse, under an overhang, amid a pile of logs, or in dense vegetation.

Most butterflies sleep alone, but Zebra Longwings are known to roost in communal groupings. If roosting spots can be identified, it makes it easier to find and photograph dew-laden butterflies in the early morning.

### Seeking Shelter

In rainy or cool weather, most butterflies seek shelter in crevices, under leaves, branches, or in woodpiles. Cool or rainy weather tends to

*A Red-spotted Purple (Limenitis a. astyanax) rests on a pear tree leaf after feasting on the ripe fruit. Perhaps it is digesting a meal or getting ready to go back for more.*

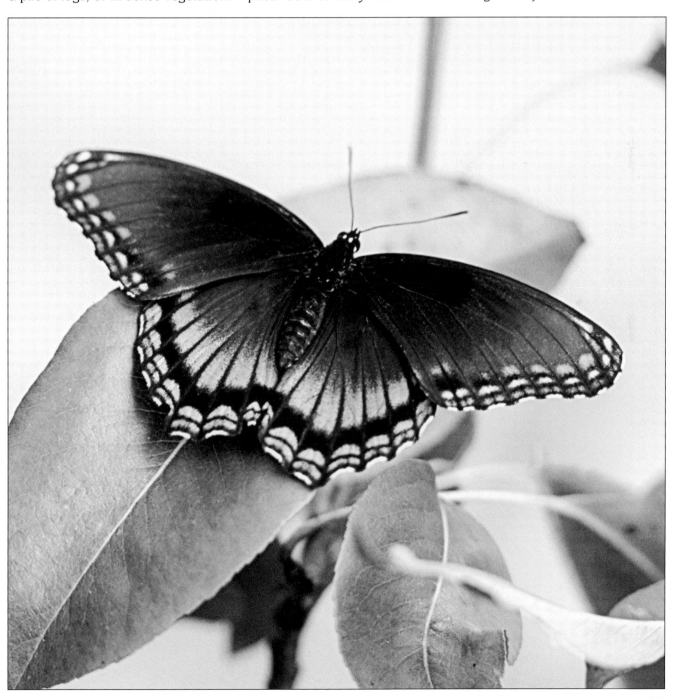

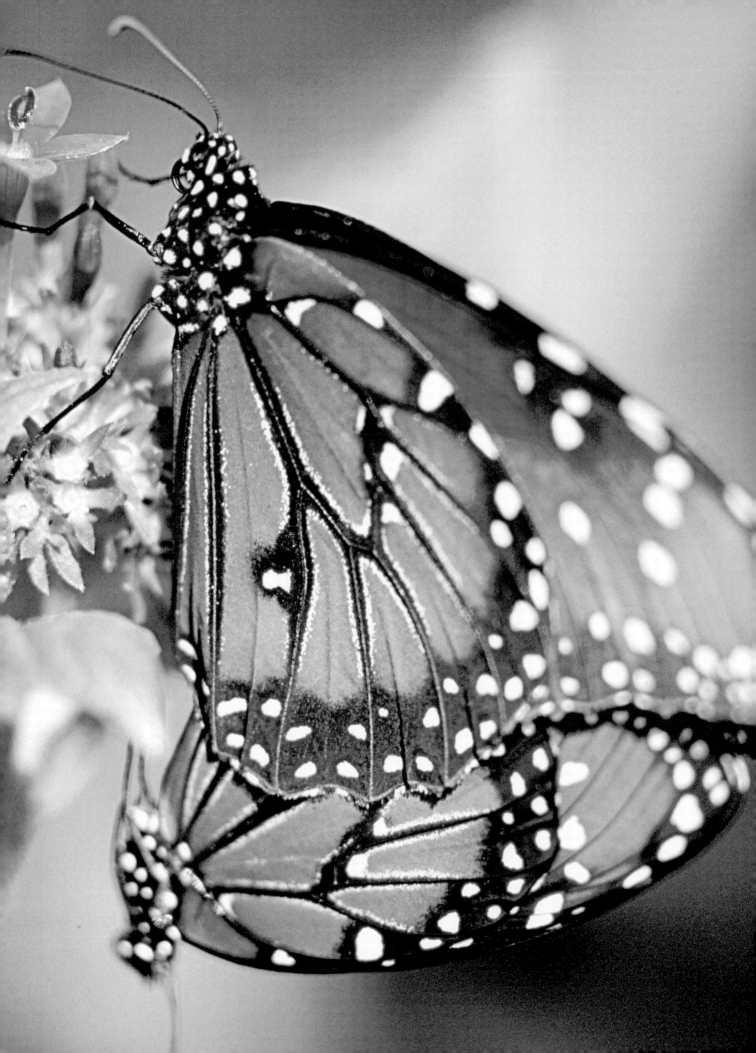

keep butterfly activity to a minimum and makes them easier to photograph when they can be found. This may be an excellent time to photograph butterflies since they won't be going anywhere. Unfortunately, rainy weather is a difficult time for photographers and their equipment. A gallon-sized "baggie" can enclose the camera and most of the lens (use a rubber band to secure the baggie around the lens in order to keep water out). Take along lens tissue to keep the lens dry. Illumination (although uniform) is low and so a "fast film," a flash unit, or a tripod might be advisable. How to photograph in low-light situations is examined elsewhere in this book.

## Patrolling

Some male butterflies fly a pattern around their territory seeking females or intruding males, and returning to the same spot every fifteen minutes or so. Most of these are usually flying too high or too fast to photograph. Male butterflies may also be seen flying along ridges, on hilltops, or in valleys where they can observe their territory. Careful observation may help the photographer locate the perch or other spots where rivals or females can be found.

## Mating

Once butterflies emerge from their pupal state, they are mature and ready to reproduce. The lifespan of adult butterflies can range from a few days to nearly a year for the migratory Monarchs. Mating is a fleeting encounter and the challenge of finding a pair of mating butterflies is formidable.

*Opposite: Two Queen butterflies (Danaus gilippus) photographed while mating.*

If one is fortunate, mating is a good time to take photographs because the butterflies are preoccupied in a critical part of their life cycle, are less easily disturbed, and often sit still longer. Mating can take several hours, but it can also take just a few minutes. Thus, it's important to start photographing as quickly as possible. A quiet, methodical approach is necessary to keep the butterflies from flying away. Methods of approach are discussed in more detail on page 34.

## Egg-Laying

Egg-laying is another opportune time to take pictures since the female is preoccupied and is more tolerant of a quiet approach. After mating, the female seeks out very specific host plants on which to lay her eggs. If she cannot find the host plant necessary for the survival of her offspring, she will simply not lay. Thus, females can be seen flying low over the ground, landing and touching various plants with their antennae or proboscis before lifting off again. Some use scent organs on their feet to locate a suitable healthy plant.

Once a host plant is found, the female bends the tip of her abdomen down to deposit an egg on the top or bottom of a leaf. Most butterflies lay only one egg on a single leaf or grass blade. Some groups, like blues, lay eggs on un-opened flower blossoms. A few however, such as the Checkerspots and Mourning Cloaks, may lay 10 to 300 eggs at a time.

There are two difficulties photographing females that attach their egg to the underside of a leaf. Most often, the top half of her body will be illuminated, while the lower half will be in shadow. Use of a fill-flash

### □ Flyways
*Some species, such as the Giant Swallowtails, patrol "flyways" along riversides. Often these flyways remain in place over many years. Both sexes can be seen using these flyways.*

### □ Migration
*During the fall migration there are several "hot spots" or "jump off" points along the East coast where butterflies can be found by the thousands. Cape May, NJ, is one such point. Migration routes are like flyways. Monarch migration routes are easy to find, as these butterflies head to their wintering grounds in Southern California and Mexico.*

*An Asian Monarch (Danus chrysippas) laying eggs. This is a poor photograph; shallow depth of field, a blurred seed pod in the foreground, and no clear idea of what the butterfly is doing. It does, however, illustrate the difficulties in taking photos of egg-laying females.*

## How to Approach Butterflies
### *Move Slowly, But Decisively!*

You'll have much better luck if you wait until the butterflies are feeding, drinking, puddling, or mating to approach them. Their interest will quickly shift from you (the intruder) to their normal routine. Butterflies that flew off in alarm may fly back and resume their activities. At that point, it is important to move in slowly, but decisively. Very important: butterflies do *not* tolerate sudden or jerky movements!

Children love visiting butterfly worlds, and butterflies in those confines frequently land on a child's arm or shoulder to the delight of all. Children are generally not frightened by these delicate creatures and are usually in awe of their delicate beauty. You usually don't have to worry about children harming the butterflies, because the insects are quick to take flight if disturbed. If you have children or a dog, they can be very helpful in finding butterflies, but if their natural exuberance and desire to help is unrestrained, butterfly photography in the wild will be more challenging.

One photographer had a cat that enjoyed taking early morning walks. It didn't take long for this cat to discover that the photographer was looking for something in "her territory." As it happens, this cat was an expert in finding things close to the ground and it required considerable patience to curb her pouncing tendency until she would sit quietly and watch the photographer take his pictures. Only her twitching tail gave a sign of the continuing struggle to control her instincts. When she could stand it no more, she would leap. Fortunately, the butterflies always managed to

or a strategically placed reflector that projects light upwards helps illuminate the bottom part of the butterfly. Another difficulty is that the leaf may block either the top or bottom of the butterfly while the egg is being deposited. Taking multiple photographs of egg-laying from different angles is the only sure way to guarantee that both top and bottom halves of the butterfly are captured during egg-laying.

elude her and that would end the session.

If the butterfly is approached slowly, the patient photographer can literally move within inches of the insect without causing any fright or flight. Careful tests in the field demonstrate that this really works. Such trials give the photographer insight into how close one can get to a particular species of butterfly before it flies off. All have a "flight zone" that must be determined. For some species it is a few feet, and for others a few inches. Sometimes a butterfly will flex its wings in preparation for flight. If you back away slightly, the butterfly may remain. A skittish butterfly will require a more powerful lens coupled with a higher shutter speed setting. A butterfly that tolerates a close approach permits the use of macro (or micro) lenses and slower shutter speeds.

### Avoid Casting Shadows

Although butterflies are tolerant of slow movement, they do not like shadows! They may perceive a shadow as an approaching predator and if a shadow crosses them, they are likely to fly off. Since photographers like to have the sun at their back, this can produce some awkward

poses, so crouch down a bit, shoot from one side, or use a fill-flash or reflector.

### Identify Host Plants

The more one is able to recognize flowers, herbs, grasses, bushes and trees, the better the chance of finding specific butterflies associated with that plant. Most butterfly books identify important host plants by name, and it's also useful to buy, study, and carry along a plant field guide.

□ **Butterfly Vision**
*A tip: butterfly eyes consist of thousands of individual lenses that allow the butterfly to see almost all around it without turning its body. However, the lower lenses are used to see close-up and are used in feeding. Thus an approach from below the butterfly or directly behind the butterfly might be more successful than one from above facing the subject where it can see objects at a greater distance.*

*The author's right hand was under this resting Queen (Danaus gilippus) while taking its picture. Not a recommended photo technique, or a very good picture, but it proves the point. Move slowly!*

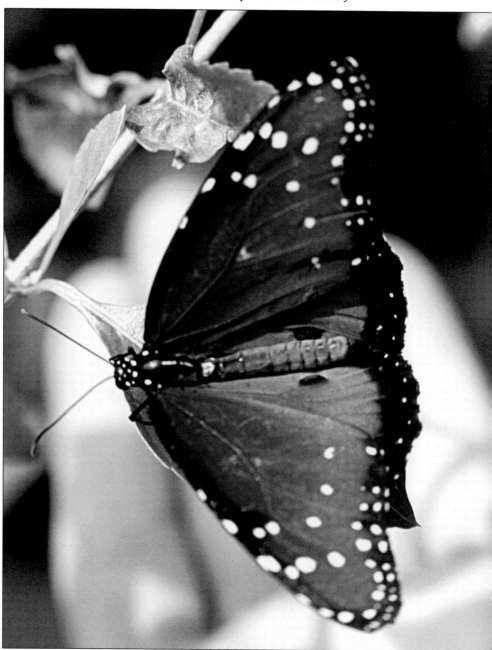

*The pawpaw tree (Asian triloba) is an vital host plant for Zebra Swallowtails. This spectacular butterfly usually fails to adapt to suburban growth, but is found along the banks of the Potomac River around Washington, D.C.*

"Butterflies have a keen sense of smell..."

### Avoid Perfume, After-Shave, Sunscreen, and Sprays

Butterflies have a keen sense of smell and do not appear to be attracted to the scent of perfume, after-shave lotion, or sunscreen. However, perfume does attract wasps and bees as annoyed picnic-goers have discovered. It's best to forgo perfumes or after-shave when heading out to photograph in the field. Obviously, sprays or lotions designed to ward off mosquitoes, gnats, and ticks may repel butterflies. Unfortunately, sunscreen and insect repellents are important in the field and should be used. If unscented products can be applied, that would be an ideal solution to the problem. Those who are allergic to bee stings should anticipate interactions with bees and wasps and seek other subjects to photograph. Inevitably, a bee or wasp will land to investigate your clothing or skin. It takes tremendous control to avoid slapping at the insect, but don't! They are looking for food and after wandering around for a few seconds will fly away. However, if you swat them, they react angrily with painful consequences, so try and remain calm (which is, admittedly, hard to do) until they leave. Unfortunately, bees and wasps gather wherever butterflies are found.

### Try Sweat

Dr. Robert Michael Pyle is able to attract butterflies to a finger after wiping his brow with it (since butterflies need salt, they find a salty finger an attractive place to visit). He slowly places his hand near puddling or feeding butterflies or sometimes takes a butterfly from a net and places it on a finger. He then delights children by placing the butterfly on their nose, where it sometimes stays to feed on the salty skin, or simply bask.

### Wear Bright Colors

Butterflies are attracted to bright colors, especially those that reflect ultraviolet wavelengths. Thus, one might try wearing purple, blue, yellow, or white accessories. Patterns (butterflies or flower prints?) might be more effective than solid colors. Be aware, however, that such colors may also attract stinging or biting insects such as bees, wasps, and mosquitoes.

### Know When to Give Up

Frankly, there are times when one simply cannot take photographs of butterflies. Don't try to photograph butterflies in mid-air – some of them fly from flower to flower at a speed that makes watching frustrating, much less photographing. Others fly amid the branches of the highest trees while some conceal themselves so masterfully that they are impossible to find. And sometimes butterflies simply can't be found when and where they are supposed to be. Cold weather, spraying of insecticides or herbicides, heavy rains – all can have a negative impact.

Don't be surprised when some brightly patterned butterfly suddenly drops completely out of sight as you're running just a few feet behind it. Many butterflies have brilliant colored wings on one side and dull earth-toned colors on the other side. When they drop to the ground and close their wings, they become nearly invisible – seemingly disappearing into thin air. But don't consider such disappearances a defeat – there is always tomorrow.

"Butterflies are attracted to bright colors..."

# The Tools of the Trade 3

Before examining photographic gear, equipment, and film, it may be useful to review aperture and shutter speed, both because they play key roles in photography and because they are discussed extensively in this and other chapters.

Aperture settings (called f-stops) control the amount of light that passes through the lens, and these settings are found on the aperture control ring on the lens. In dark settings (late evening or indoors), a low aperture setting (e.g., f2) permits a large amount of light to enter through the lens and be registered on the film. The amount of light decreases incrementally as subsequent settings are selected (e.g., f4, f8, f11, etc) until only a small beam is admitted at the higher f-stop settings (e.g., f22, f32 or f64) that are needed in very bright conditions or when used with a flash. The importance of aperture is that it determines focus (called depth-of-field). A setting of f2, for example, has a very narrow depth-of-field and both the foreground and background will be out of focus as well as part of the subject. This may be desirable since

"... butterfly photography generally requires the use of close-up lenses..."

the background can be distracting in some instances.

By contrast, a setting of f32 provides greater depth-of-field resulting in more defined images. This is important in butterfly photography because most photographs are taken in close proximity to the insect and the closer one gets the harder it becomes to get everything in focus. Also, butterfly photography generally requires the use of close-up lenses, special adapters (extenders or multipliers) or filters (polarizers), or lower speed films that require lots of light to function effectively; this translates into a loss of f-stops. Although it is desirable to use high aperture settings for maximum depth-of-field, in practice high aperture settings usually require conversely lower shutter speeds.

Shutter speeds also control the amount of light that is registered on the film, and these settings are found on the camera. A low shutter speed (e.g., 1/15th of a second) allows more light to enter than a high shutter speed (e.g., 1/2000th of a second). Low settings frequently regis-

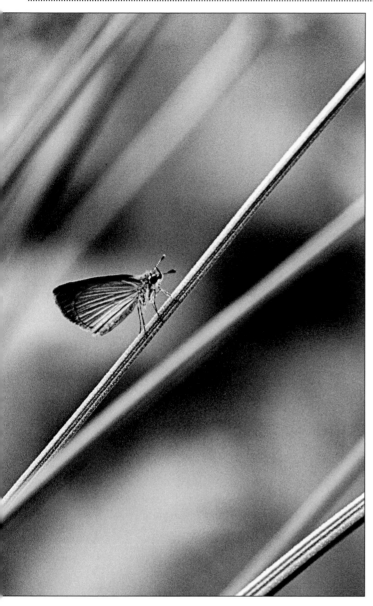

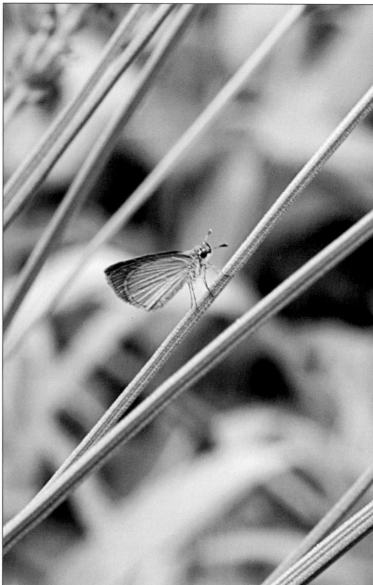

ter motion (either the camera or subject moving), thus producing a blurred or fuzzy picture. High shutter settings, on the other hand, might be able to stop unwanted motion, but require a lower aperture setting to permit sufficient light to be registered on the film. Shutter speed settings for most butterfly photography usually range between 1/60th and 1/250th of a second. A butterfly sitting motionless, however, can be sometimes be photographed at shutter speeds of 1/30th of a second or less (especially if using a tripod). Most images, however, involve butterflies fluttering their wings or moving about while feeding, and a shut-

ter speed of 1/125th to 1/250th of a second is generally recommended. Shutter speed is also tied in with the power of the lens being used and whether or not the camera will be hand-held (more about that later in the book). Unfortunately, high shutter speeds usually require low aperture settings.

All photography is based on this see-saw relationship between aperture and shutter speed. A combination that allows too much light to strike the film plane produces an overexposed picture while too little light results in an underexposed image. A brilliant sunny day at the beach or

*Left: A Least Skipper (Ancyloxypha numitor) waiting for an approaching storm. ISO-100 speed film with an aperture of f2 set at 1/500th of a second. Note the soft, blurred background, but the Skipper is in focus because it is at a horizontal angle.*

*Right: The same skipper photographed at f32 at 1/8th of a second. Notice the difference in the depth of field.*

*This photograph was taken in full sun with ISO-100 speed film, using an 80-to-200mm zoom lens with an extender. A normal setting would be 1/125th at f11. However, to demonstrate motion, the shutter speed was set to 1/15th of a second and the aperture increased to f32. This was far too slow to stop the motion of the butterfly, and the high aperture setting produced a distracting background.*

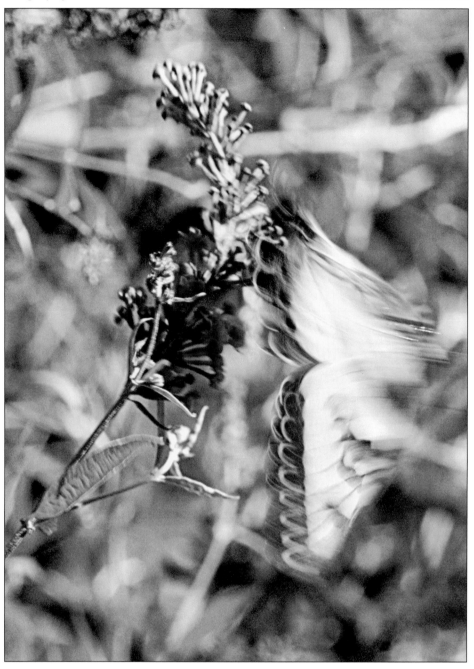

"Single lens reflex
cameras allow
the use of several
different lenses."

ski slopes, or when using a high-powered flash, are the few exceptions that may allow both the high aperture and shutter speeds necessary to produce acceptable results. This will be considered elsewhere in this book. The relationship between aperture and shutter speed is a difficult concept, but when mastered, beautiful pictures can be produced. Readers who are not clear about this are urged to read Craig Alesse's *Basic 35mm Photo Guide* (Amherst Media, Inc.) or Jack Neubart's *The Photographer's Guide to Exposure* (Amphoto) to fully understand and appreciate this principle of 35mm photography. Other informative books are listed in the appendix.

### □ Cameras and Lenses
### *Single Lens Reflex (SLR) Cameras*

Single lens reflex cameras allow the use of several different lenses. SLRs are lightweight, maneuverable, and able to admit a bit more light than

medium-format cameras. The SLR is preferred by many for butterfly photography.

• Fully Automatic Mode

Many photographers selected their initial camera system precisely because it could automatically make all adjustments necessary for good pictures. The fully automatic (or programmed) mode is recommended especially for individuals beginning to take photographs. Fully automatic cameras use in-camera software and metering systems to automatically adjust settings, and these usually produce acceptable results in most situations. However, other options exist for butterfly photography that sometimes produce much better photographs than a camera in the fully automatic mode.

• Aperture-Priority Mode

The aperture-priority mode allows the photographer to select an f-stop, with the camera choosing the proper shutter speed based on the lens, the speed of the film being used, and the light being reflected off the subject. Butterfly photographers usually want the smallest aperture possible, typically f16 or f22 to obtain maximum depth-of-field (the area in focus). When aperture-priority is selected and the camera set to operate at f16, for example, the shutter speed will fluctuate depending on whether the subject is in the shade or in full sunlight and whether the butterfly is light or dark. Unfortunately, shutter speed may fall below the point where the user can hand-hold the camera, and this results in blurring. More importantly, the camera cannot detect whether a butterfly is sitting still or moving, or whether it is fluttering its wings rapidly. This can produce a blurred image. Aperture-priority is

not recommended for butterfly photography.

• Shutter-Priority Mode

For many photographers, the shutter-priority mode is a good option. The photographer chooses a speed (e.g., 1/250th of a second) and the camera chooses the proper aperture setting, based on the lens, the speed of the film being used, and the light being reflected off the subject. This is one of the better choices for butterfly photographers. High shutter speeds stop both butterfly movement and camera shake, either of which can ruin an image. Careful focusing will result in at least some of the butterfly being in focus, but one can quickly lose depth-of-field if inattentive.

• Manual Mode

Photographers with a solid understanding of the basics of photography know that success involves a subtle interplay between aperture and shutter speed. Control over these two features is critical to generating superior images. The importance of being able to control the camera in manual mode is covered extensively in this book.

### Autofocus

There are many autofocus cameras on the market today. These systems allow for rapid focusing, but pose two problems. First, butterfly photography requires the photographer to focus on the eye of the butterfly, and focusing on one that is pivoting and moving back and forth in close proximity to the camera requires constant focusing. Many autofocus lenses cannot handle such rapid shifts. As a result, many professionals may switch the autofocus mode to the "off" position to manually focus the camera.

"Control over these two features is critical..."

## "... go into the field with extra batteries..."

A second drawback is that autofocus systems rapidly drain internal batteries needed to keep the system operational. It is wise, therefore, to go into the field with extra batteries – both for the autofocus system and for use in fill-flash situations.

One advantage is that butterflies are not frightened by the sound of the autofocus system; many animals would flee at the first sound of an autofocus in action. This is a useful consideration when debating the pros and cons of an autofocus system.

### Exposure Compensation

Some cameras can be programmed to automatically "bracket" in small steps from slightly underexposed to slightly overexposed. Bracketing involves keeping either the aperture constant while changing the shutter speed above or below the "ideal" setting for the picture or vice-versa.

*The settings for the ISO are shown on the left and those of the exposure compensation are on the right.*

This makes the subject slightly lighter or darker. In situations where the butterfly is moving rapidly, part of the butterfly may be in shadow for an instant and then in full sunlight. Bracketing can be a blessing, especially with cameras that automatically advance the film. This allows the photographer to concentrate on the butterfly and not on the camera.

Manual cameras also have a +/- feature, but once set, it only allows more or less light to enter, and does not deviate from that setting.

### Lenses
#### • Normal lenses
Many older cameras have a 50mm lens that provides the same perspective seen by the human eye (around 45 degrees). They are either "fixed" (permanently mounted on the camera's body) or removable (replaced with another lens). Some of these lenses are incredibly "fast," admitting a lot of light and allowing for extremely low-light photography. There is, however, a limit on how close a 50mm lens will focus. It's good for capturing the scene of a garden but comes up short for photographing the finer details of a butterfly. Fortunately, there are relatively inexpensive magnifying lenses (attachment lenses, usually numbered from zero to six) that can be added to the front lens.

#### • Macro ("Micro") Lenses
There are several macro (or "micro," depending on the manufacturer) lenses available, including the 55mm, 60mm, 105mm, and 200mm for extremely close work.

If photographs of butterfly eggs, a chrysalis, or even caterpillars are desired, then the close-up feature of the macro lens is a good choice. With a bellows and a flash lighting system, the lens produces even tighter close ups. These subjects

*Opposite: This Red-spotted Purple (Limenitis a. astyanax) was photographed using a 55mm micro lens at minimum distance. Most butterflies won't tolerate such a close an approach, but this photograph shows that it can be done.*

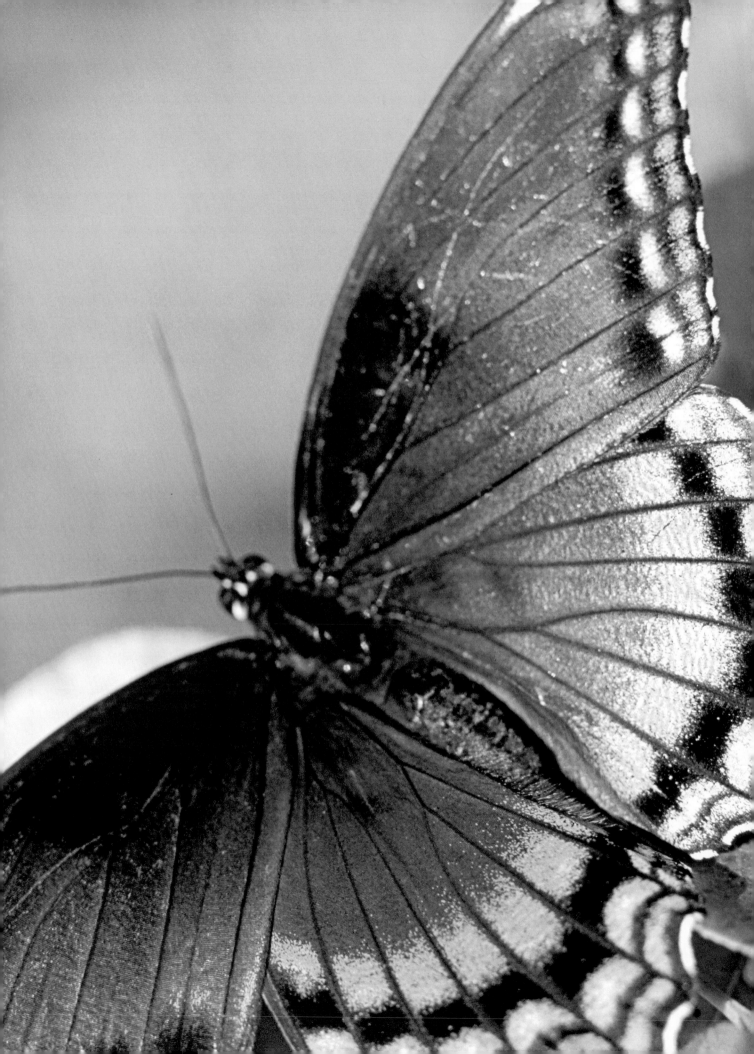

"... when a close approach is possible, results can be excellent..."

don't flutter or fly off, allowing for careful light readings and an approach within inches. Exact focus is necessary for precision photography and a tripod is essential. The greater the magnification, the more critical is depth-of-field. Flash is required at very close range.

The 55mm and 60mm lenses do not always work well for photographing some butterflies, because the front of the lens must get within inches of the subject before it's fully effective. Many butterflies may be frightened away unless approached carefully. However, when a close approach is possible, results can be excellent, especially for the tiny butterflies.

Macro lenses take great close-ups if and when the butterfly allows a close approach. The image of the Red-spotted Purple Admiral was taken with a 55mm lens. With some of the tiniest butterflies, it might be wise to try a macro lens, provided it does not get too near and frighten them away. The tiny Blues frequently don't fill the frame of the 80-to-200mm zoom lens, but a macro lens might work perfectly.

A 105mm macro lens allows the photographer to work at least a foot from the subject and still get fine images. Because it allows for a full-frame view at a slightly greater distance and also serves as a great portrait lens, this might be a good investment. The 200mm macro lens should be considered as well, because it allows for a full-frame image at a distance that is well beyond most butterflies "danger zone" (where they take flight).

• Zoom Lenses
As noted, many lenses can be used for butterfly photography, but the most effective, in the author's opinion, is an 80-to-200mm zoom lens. Many of the butterfly photographs in this book were taken with a 80-to-200mm zoom with an extension ring (see below), but other good choices are the 70-to-150mm or 75-to-200mm lenses, as well as fixed lenses in the 150mm to 200mm range.

□ **Advantages of Zoom Lenses**
- The butterfly is not as likely to be stressed or startled;
- The photographer can maintain a safe distance, but still get a good close image;
- The photographer can hand-hold the camera;
- Distant, medium, and close up photographs are possible;
- An "extension ring" can be added for maximum focus of close-up work, and
- Superb clarity can be achieved.

• Telephoto Lenses
Although not often associated with butterflies, telephoto lenses can produce beautiful results. A 200mm, 300mm, 400mm, 600mm or even a 1,000mm lens, with one or more extension rings can produce fine close-ups ("close up" being a relative term, since the subject is several feet away). However, the telephoto lens must be mounted on a tripod as close as possible to the subject. It is important that changes to the focus area are minimal – the photographer simply cannot track and focus on rapidly moving butterflies. A drop of sugar water might be used to keep the butterfly feeding for a few extra seconds. Light readings, camera settings, and focus all must be preset. A cable release should be used to snap the shutter for minimal vibration.

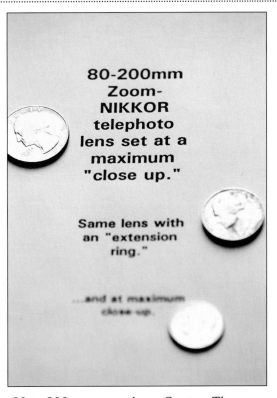

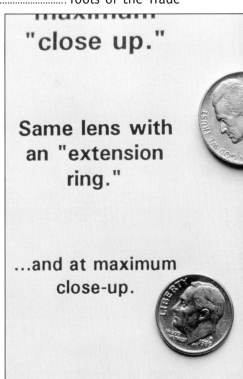

*Left: The "extension ring" with the 80-to-200mm zoom lens. Center: The center image shows the lens focused at maximum close up range without the extender. Note that the dime is both small and out of focus. Right: The photograph on the right is taken from exactly the same distance, but with the extension ring.*

The advantage of using a telephoto is that the butterfly is generally not aware of your presence. On page 47, a 600mm lens was used on a very bright, clear day with two extenders and a multiplier and ISO-200 speed film. The initial settings without the attachments were 1/250th at f16. Adding the two extenders required a lower setting of 1/250th at f8. The multiplier (see below) decreased those settings to f4. However, because the lens was on a tripod, a lower shutter speed (1/125th) was chosen and the aperture was increased to f5.6. The subjects were skippers feasting on the yellow flowers of yarrow (*Achillea sp.*) and just about any flower that appeared in the view screen was visited (usually for only for a second or two) by a skipper.

### Extension Rings for Close-Ups

The extension ring (or extender) is a very important accessory which alters the focal plane of the lens. It is not a lens (in fact it has no glass in it), but is mounted onto the camera exactly like a lens. The lens is then mounted onto the extension ring. The camera remains the same distance from the subject, but the subject now fills more of the frame. The result is close-ups from a distance that don't frighten the butterfly. The extension ring is the single best accessory for taking good butterfly pictures.

Unfortunately, adjustments must be made to the aperture or shutter speed. Typically, there is a loss of one or two f-stops (e.g., from f16 to f11 or f8) depending on the number and/or size of the extender used.

"The extension ring is the single best accessory for taking good butterfly pictures."

A 600mm telephoto can make a distant shot with ease, or with an extender, can take superb close-up photographs. Eastern Tiger Swallowtail (Papilio glaucus).

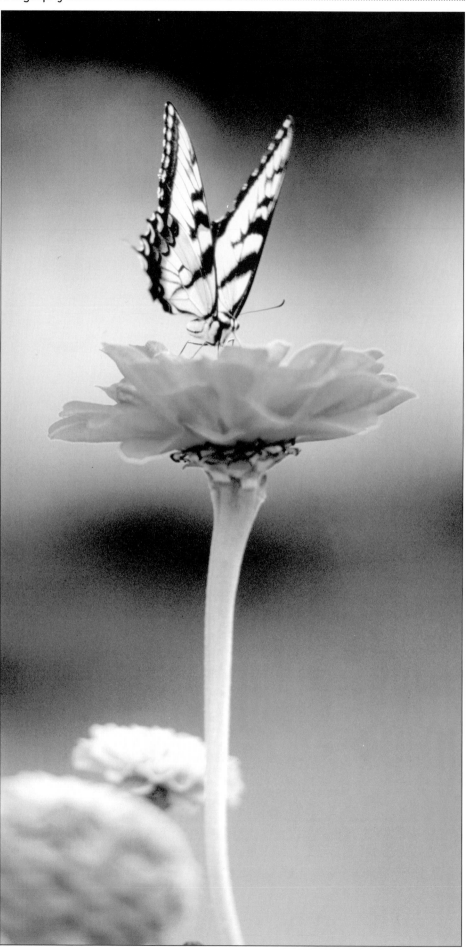

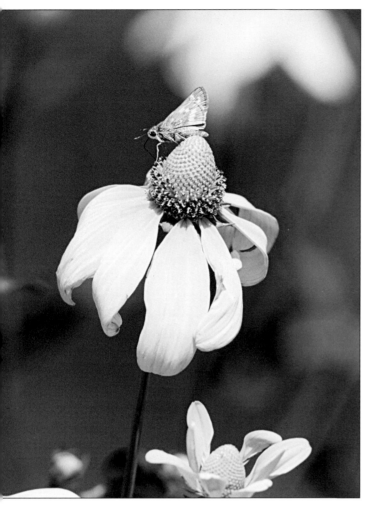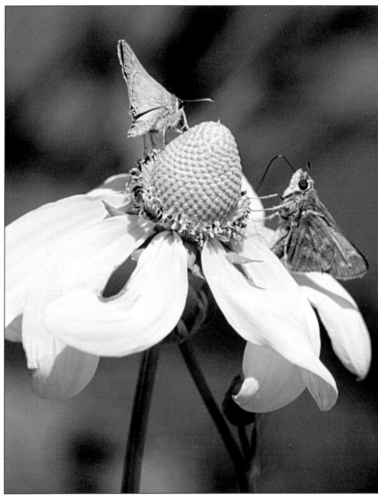

*Left: A photograph of a Sachem (Atalopedes campestris) on a coneflower taken with a 600mm lens with two extenders and mounted on a tripod using ISO-200 speed film taken at f8 at 1/250th of a second.*

*Right: The same system, but with a 2x multiplier added. This increased the power of the 600mm lens to 1,200mm and required opening up the aperture to f5.6. This photograph was taken on a sunny day, and the camera being on a tripod made this picture possible. Even so, bracketing was necessary. Note that the bright yellow coneflower blossoms reflect light up, illuminating the lower parts of the Sachems. The shadow (right side) from the sun shows that no flash was used.*

Another drawback is that the camera can only take close-ups with the extender in place. If another subject appears in the distance, the extender must be removed and the lens put back onto the camera in order to photograph the distant subject.

### Multipliers

Multipliers are similar to extenders, except they come with glass elements and instead of allowing close-ups, they extend the range of a camera lens. Multipliers are also called "teleconverters" and they come in different models. A 2X multiplier doubles the power of a lens (e.g., a 600mm lens becomes a 1,200mm lens).

Multipliers are small and less expensive than owning two powerful telephoto lenses. Unfortunately, there is a loss of about one f-stop for each degree of power. Thus, a 2X multiplier doubles the power of a 600mm lens to 1,200mm, but requires a two-fold decrease in f-stops (e.g.,

from f16 to f8). For normal photography of distant subjects, this is acceptable. However, if extenders are added, an additional loss in f-stops is required (e.g., from f8 to f5.6 or f4). A tripod or monopod is a necessity, while full-flash, fill-flash, or reflectors are sometimes needed to help compensate. As a rule of thumb, it is advisable to use a multiplier built by the manufacturer of the camera lens for the best results.

### ☐ Flash Units

There is no single brand of flash recommended for butterfly photography, and just about any make or model works fine. The reason is that distances are so short – most work is done within a few inches or feet of the subject – that any output of light works. There are some features, however, that are desirable, including the ability to adjust the output of the flash and flash heads that rotate or tilt. Fill-flash comes with some units, producing a lesser amount of light and that is important in butterfly photography. Diffusers are also desirable, and many units come with a diffuser or they can be purchased separately and attached to the front of a flash unit with Velcro fasteners. It is generally worth buying a flash made by the manufacturer of the camera, although even this is not critical. Sometimes the best use of a flash is to gently illuminate areas in the shadows and not to overpower the scene, so less expensive (or powerful) flash units frequently produce very good results.

Most butterflies appear to be oblivious to the flash, perhaps because it's like nature's lightning. Once in a while, though, a butterfly will flinch when a flash is used. Ethics followed by most nature photographers require that they not stress the nat-

ural subject, whether it's a tiny butterfly or a large mammal; good photographers should not cause anxiety or harm to any creature for the sake of a photograph.

### ☐ Hand-Held Cameras vs. Tripods and Monopods

Butterfly photography requires the photographer to move quickly when an opportunity arises, but with a steady hand. Alternatively, a tripod may prove useful because it is rock steady. A tripod allows the photographer to lower the shutter speed and increase the aperture setting, gaining better depth-of-field, but the butterflies must be feeding on one particular blossom or flower or resting in one spot. The questions is: flexibility or stability?

### *Hand-Held Cameras*

In general, the best choice for butterfly photographers is to hand-hold their cameras, because they can move quickly from one flower to another, shifting positions, angles, and reacting to new opportunities with ease. Hand-held equipment, unfortunately, is subject to shaking resulting from an unsteady hand, breathing, or zoom lens operations, especially in low-light situations. Even minor movement can result in a hazy or "soft" image if the shutter-speed is too low for the lens. There is a general rule that many photographers use to determine the likelihood of camera motion for a specific lens. If the length of the lens (say 100mm) exceeds the shutter speed (for example, 1/60th of a second), then the lens cannot be hand-held, because it probably won't produce sharp images.

This practical guidance enables the nature photographer to use a specific lens to maximum effect. The

"Butterfly photography requires the photographer to move quickly..."

trained photographer knows that a 100mm telephoto lens used with a shutter speed of 1/125th of a second will deliver sharp images if it is hand-held. However, while a shutter speed setting of 1/125th of a second with a 100mm lens may produce an acceptable hand-held image, it may be too slow to stop the rapid fluttering of a butterfly, and a higher speed may still be needed. This same lens tends to produce slightly blurred images with the camera set to 1/60th of a second, and soft or fuzzy pictures at 1/30th of a second. When working with a 200mm lens, the shutter speed should be set at 1/250th of a second and when using a 300mm, 400mm or 500mm lens, the camera should not be hand-held at any shutter speed of less than 1/500th of a second.

It is possible, though, to increase the shutter speed by using higher rated ASA/ISO film speed. Someone using a 200mm to 1,000mm lens can use a very "fast" film that allows the camera to be hand-held (although this may not be practical given the weight of more powerful lenses). Someone using a 200mm lens should consider ISO-200 film, while someone with a 300mm lens should lean towards ISO-400 film. The faster film permits the use of higher shutter speeds needed to hand-hold cameras with more powerful lenses.

Sometimes it might be necessary to sacrifice aperture settings to maintain suitable shutter speeds. The butterfly enthusiast photographing with a 200mm lens at 1/250th of a second at f16 may have to decrease the aperture setting to f11, to f8 or even to f5.6 as the sun gets lower or as clouds obscure the sun. To offset this loss in aperture (and resulting loss in depth-of-field), the use of a tripod or monopod may be necessary.

### Tripods and Monopods
• Tripods

Tripods play an important role in butterfly photography and are most effective when there is time to focus on one particularly beautiful flower. Prefocus on that single blossom and wait for a butterfly to arrive. When it does, quickly take a series of pictures. If butterflies are already feeding on a single flower, then tripods can be very helpful, allowing much lower shutter speeds and conversely higher apertures (e.g., from f11 to f22). However, butterflies are quick to flutter in and out of the field of view under the best of circumstances, and once the tripod is set up and the camera focused, it is difficult to move quickly.

Tripods are necessary for any lens over 300mm, but may be used with less powerful lenses, in low-light situations, or when using "slow" film. Tripods should be sturdy and flexible. They come in various sizes and weight, so select one that is comfortable to carry. It should have a quick-release head or mount that allows the camera and lens to be quickly and firmly mounted and legs that can be spread widely to photograph close to the ground. It should swivel easily and must be able to hold a heavy lens securely. Ball heads should be tested to make sure the lens won't tilt under the weight of a heavy lens; better ball heads have very good locking mechanisms.

With a little adaptation, the tripod can be made more comfortable to carry while walking long distances in the field. Pipe insulation (long tubes made of foam with a hole in the cen-

"Tripods are necessary for any lens over 300mm..."

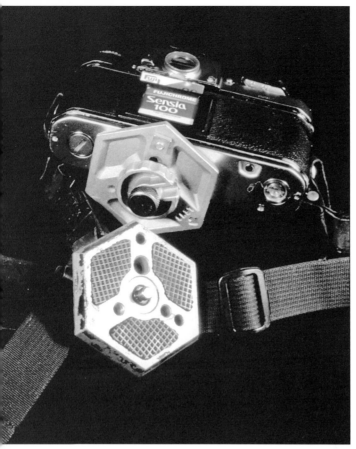

*A "Quick Release" head offers security to expensive cameras and their lenses. The head permits the camera (or lens) to slip on/off the tripod with the flick of a locking lever.*

ter and strippable sealant running down both sides) should be available in the plumbing section at large hardware stores. These can be wrapped around the upper part of the tripod legs and sealed and then secured with a strip of electrical tape on both ends. They are also more comfortable to touch or hold in very cold weather.

• Monopods
Monopods consist of one extendible leg with a head that accepts most camera or lenses and permits a camera to be shifted quickly from side-to-side or from front-to-back. They are light-weight, easily carried from one location to another and can be an asset to those who are concerned about camera motion when hand-holding cameras with more powerful lenses or when using low ISO films. Many professional sports photographers use monopods with very heavy lenses, knowing that they must move quickly when necessary. Monopods allow use of more powerful lenses at lower shutter speeds (permitting smaller f-stops) which is important to photographers seeking maximum depth-of-field. Some monopods may be difficult to move up-and-down quickly in the field, although some allow the photographer to adjust the height by squeezing a handle. Because it has only one leg, it must usually be held, although some models do permit legs to be attached. Monopods are

relatively inexpensive, compact, easier to move than a tripod, and should be considered for possible use in the field.

## ☐ Filters
### Ultraviolet Filter
Butterflies see ultraviolet light, whereas humans cannot see very far into the violet or ultraviolet spectrum of light. There is an ultraviolet filter, called the Wood's glass (OX1) filter, which allows light below 400 nanometers to pass through the glass and be registered on film. Because the filter is almost black it requires an exposure increase of 12 stops! However, use of that filter generates photographs of what butterflies see in their world. For example, what humans see as a solid yellow blossom could be recorded as a blue and white pattern that guides insects to the pollen-rich center of the flower. Adventurous butterfly photographers, as part of their portfolio, might wish to record ultraviolet images of flowers visited by butterflies. Butterflies themselves also have patterns (not seen by humans) that aid in the recognition of potential mates (or competitors), and the ultraviolet filter can also reveal these markings. This UV filter should not be confused with the common "haze" filter, which is also called a "UV" filter. The author has not used this filter and cannot offer any personal advice on its use.

### Warming Filter
The "warming" filter, or amber filter, helps overcome blue hues, especially for subjects in the shade on a bright day. The 81B warming filter shifts the color temperature from a bluish tinge (7,000 Kelvin) to the light found at noon on a bright, sunny day (5,500 Kelvin).

## Circular Polarizer

A circular polarizer enhances color saturation, producing very rich colors. A polarizer also helps remove glare on leaves, and reflections from water or glass. It should be used at right angles to the sun, and it's not effective with direct sun light or a flash.

The polarizer is screwed onto the end of the lens. When viewed at a 90-degree angle to the sun, the image changes from relatively unsaturated to deeply saturated while rotating the polarizer. Although most "through-the-lens" (TTL) metering systems work well with a polarizer, the photographer is encouraged to set the camera on manual and use a gray card or the palm of the hand to obtain an accurate light reading (see Chapter 4).

If the proper light reading is f8, the photographer should bracket between f8 and f7 when the subject is deeply saturated. Adding just a little extra light is especially necessary in the western states, or in high elevations, where skies sometimes turn out inky blue. A few test rolls with notes will point to the need for modifying settings if the photographs turn out too dark. If the butterfly is white or yellow, bracket in tiny increments from f8 to f10.5 or even f11. If the butterfly is dark, bracket from f8 to f7 down to f6. These settings are not marked on the lens but are small adjustments that can be made between the settings, allowing for a touch more light for dark subjects and a bit less for light colored objects. Some images will be slightly over- or underexposed, but that's why

*Similar views taken with (left) and without (right) a circular polarizer.*

several shots at different settings should be taken.

The disadvantage of using a polarizer is that it "costs" two full f-stops. Thus, instead of photographing at 1/250th of a second at f16, the polarizer requires the settings to be decreased to 1/250th at f8 or 1/125th at f11. In addition, polarizers don't work very effectively in the shade and might not be worth the loss of two f-stops. Those two extra stops can be used to increase the area of focus, and that is an important consideration. When shooting in the shade, remove the polarizer.

## □ Film

Both slide and print films have advantages in butterfly photography. For projecting images in lectures or marketing images to magazine or book publishers, color slides (color reversal film) are best. But, for exhibiting at art galleries, print film (color negative film) is preferable. Professional film is available, but generally at a higher price than normal consumer film. Professional film must be kept refrigerated and should be processed immediately. The film is usually at its technical "peak" and may produce slightly more saturated images.

Advanced amateurs as well as professionals are encouraged to try ISO-25, ISO-50, or ISO-64 speed film because of the greater resolution of the film. That means a reduction in shutter speed – which makes it increasingly difficult to hand-hold the camera. The photographer should maintain a shutter speed of 1/125th of a second but "open up" the aperture (e.g. 5.6 or even 3.5), to produce acceptable images, but with a limited depth-of-field. Two small fill-flash units (with diffusers) allow the photographer to increase the aperture to a higher setting. A top- or side-mounted full-flash unit set to a fill-flash setting might push the f-stop up even more, thus increasing the depth-of-field. At some point, however, shadows may become a problem, but low ISO rated films produce such wonderful images that they are worth trying.

In summary, lower ISO speed films produce high resolution photographs. But it also becomes harder to hold the camera steady and the depth-of-field becomes narrower with slower films. Films are changing so rapidly that a whole new family of film may well be available after this book has been published. Review the latest films with a camera dealer and try a variety of different types of film.

"Both slide and print films have advantages..."

# Lighting in Butterfly Photography

# 4

Proper lighting is critical to all photography, but successful butterfly photography poses some unique challenges. Too much light produces a washed out, overexposed image, while too little yields a dark, underexposed image where details can't be seen. With proper lighting, the ability to produce sharp, properly illuminated images with great depth-of-field increases dramatically. Very few people know how much work goes into getting the light just right for that "wow" image.

Individuals with "point and shoot" cameras need not read this section, although it does provide a great deal of useful information if the reader plans to purchase a 35mm SLR in the future. Why? Because point-and-shoot cameras generally do not allow for manual control of aperture or shutter settings.

When photographing butterflies, two types of light will be encountered: direct (or ambient) and reflected. *Direct light* is light shining upon a subject, either from the sun or from a flash unit. *Reflected light* is the light being reflected off a subject.

Sunlight on a field of flowers is direct, ambient, or natural light. In that field of flowers, however, there are usually several different species butterflies dancing from one flower to another. Yellow or white butterflies, for example, reflect more light than blue or black butterflies, which

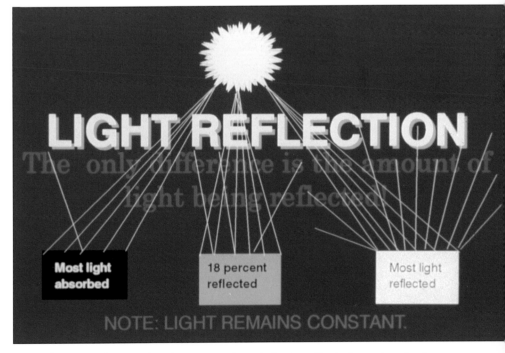

*This drawing shows what happens when light is reflected or absorbed. Although the source of the illumination (the sun) remains constant, the dark object absorbs more light particles and the light object reflects more light particles. This misleads the camera, which is set to measure 18 percent gray.*

absorb more light. The photographer must be able to measure three different potential light sources: (1) the light coming directly from the sun (or flash), (2) the light being reflected by the light butterfly, and (3) the light being reflected by the dark butterfly.

## ☐ Measuring Light

The secret to stunning photography is the accurate measurement and use of light. Unless light can be precisely measured, the amount of light being registered on the film plane could be either under- or overexposed. Sometimes this type of exposure can be effective, provided the photographer understands why under- or overexposing an image may become necessary.

### *Why Light Can Deceive*

Through-the-lens camera metering systems are deceived by reflected light. If one were to photograph an Eastern Black Swallowtail "on automatic" followed instantly by a Checkered White, the camera readings would be different and the resulting photographs possibly not as good as desired. The reason is that camera meters are calibrated at the factory to read 18 percent gray, the average reflection of human flesh tones, grass, rocks, and many other items in nature. Internal metering systems are generally not designed to accurately measure light being reflected off polished items, highly reflective surfaces (white or yellow wings), or objects that absorb light (blue or black butterflies). If the frame is

filled with an Eastern Black Swallowtail, the camera's meter is programmed to read an average reflection of 18 percent gray (e.g., it is taking a picture of a person, because that's what most people use their cameras for). But the butterfly is black not gray, and the camera overexposes the subject. The Checkered White, on the other hand, is underexposed.

The two photographs shown on page 55 illustrate this deception. The amount of light illuminating both scenes was identical (artificial tungsten light), but the background for the image on the left was a bright white, and for the right the background consisted of an absorbent black velveteen. The camera was set on automatic and the camera's internal light meter adjusted the settings for what it was designed to read as "normal" (e.g., 18 percent gray). The results are not acceptable.

### *Tricking the Camera*

Fortunately, there are procedures that allow the photographer to adjust the camera's metering system to automatically correct for dark or for light butterflies (but not both!). In some cameras, there is a + or - exposure feature that under- or overexposes a subject by small increments. The Owner's Manual for your camera provides details on exposure compensation. On more advanced systems, the camera can be set to automatically bracket up (+) or down (-). If the photographer sets the exposure compensation settings to allow for additional light, it is important to return those settings back to normal after photographing a black butterfly. Otherwise the next European Cabbage White or Yellow Sulphur to be photographed will be overexposed.

*A hand-held light meter recommends an aperture setting of f8 at 1/120th of a second using ISO-100 speed film for this level of illumination.*

Another procedure is to deliberately adjust the camera's ISO film speed setting slightly above or below the manufacturer's recommendation. This is possible with manual cameras, and with some that are programmed to automatically read film speed each time a fresh roll of film is inserted. To photograph a black butterfly with a manual camera using ISO-100 speed film, adjust the ISO setting to the next lowest setting (e.g., 80), but *not* down to ISO-64 or 50! To photograph a white butterfly, set the meter to ISO 125 – not higher. Again, you must remember to return those settings to normal (e.g., ISO-100) when you are finished, or other photographs may not turn out properly.

Professional photographers using highly saturated films sometimes set the ISO setting slightly below the stated rating and get consistently good photographs. High-contrast slide film may produce slightly better results with a bit more light, but print film works best when used at the rated ISO. It is worth a roll or two to experiment. If you don't like the results, go back to the recommended ISO film speed.

### Bracketing

Frequently it is necessary to deliberately set the camera's setting above or below those recommended by the camera's internal light metering system, by hand-held light meters, or even with gray cards. Typically, adjustments are made in tiny amounts (e.g., 1/4th or 2 f-stops) to add a bit more light for dark subjects and to increase the aperture for lighter subjects. Bracketing works in direct sunlight and in the shade.

*The image on the left was exposed for white; details on the antelope cannot be seen. The photograph on the right was exposed for black; details on the antelope are easily seen. On the left-hand image, the statue's head is under-exposed, while on the right it is over-exposed. Neither image is ideal. The camera was set on fully automatic for both exposures.*

The series of photographs that follows shows a light reading of f8 at 1/125th of a second using ISO-100 speed film was recommended for this setting (in the shade during the late evening). The first image of the Eastern Tiger Swallowtail (*Papilio glaucus*) was made at the recommended settings. The second image, however, was one in a series where the aperture was gradually increased to allow a bit more light, even though the butterfly is bright yellow. In full sunlight, it would have been necessary to reduce the amount of light by shifting to a higher f-stop.

The final image probably was taken between f7 or f6.5 at 1/125th of a second.

### Tips for Accurate Readings

There are several inexpensive – but very effective – methods to obtain accurate readings using the through-the-lens (TTL) features of many cameras.

• Gray Cards

Gray cards (8"x10") are manufactured to reflect exactly 18 percent gray. Camera metering systems are calibrated at the factory to provide

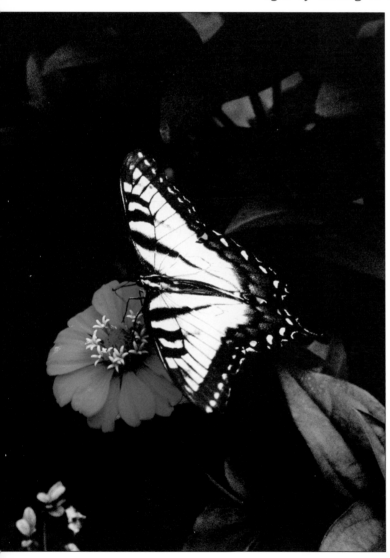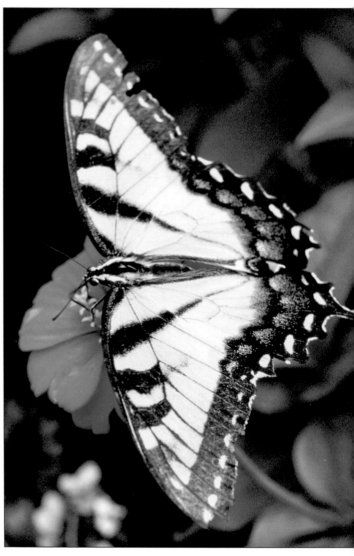

*An Eastern Tiger Swallowtail (Papilio glaucus) taken f8 at 1/125th of a second on the left and bracketed to approximately f7 at 1/125th of a second on the right. This is the normal procedure for dark butterflies. In bright light, it would have been necessary to bracket to f9 or even f10 while maintaining a shutter speed of 1/125th of a second.*

the best exposure for a rated film at 18 percent gray. Thus, if the illumination in a specific area is measured using a gray card, the camera's through-the-lens (TTL) metering system provides the user with the setting necessary to take a perfectly exposed picture. Obtaining a reading is fairly simple. Tilt the gray card slightly away from the camera to avoid a reflection. Look through the image-finder and move the card towards the camera until the frame is completely filled by the gray card. Adjust the camera's aperture and/or shutter speeds until a perfect exposure is indicated. With manual cameras, no further adjustments are needed. Automatic cameras may allow the user to "lock" onto that reading. Now, no matter what is photographed next, either a dark blue swallowtail or a bright yellow sulfur, the exposure will be close to perfect (but try subtle bracketing, just to be sure!). A gray card measures light with or without a polarizing filter on the lens, something a hand-held meter can't do.

Buy a gray card and cut it into four squares that easily fits in a pocket for fieldwork. Once at the locale, set the camera's controls to manual and the shutter speed at the speed of the film (e.g., 1/125th of a second for ISO-100 speed film). Next, a take a reading from the gray card in full sunlight. Adjust the aperture until the camera's meter shows that a proper exposure can be made (e.g., f16) – this is the "constant" reading.

So long as the sunlight stays the same (no clouds drift in), the camera will photograph dark or light butterflies without over- or underexposing them. This technique fails if the light reading is taken in sunlight, but the subject is in the shade. Both the gray

card and the subject must be in the same illumination to obtain a proper reading.

*A careful reading is taken using a gray card.*

### • Using Your Hand

Some astute readers may have already figured out a quick and easy way to take accurate light readings: using their own skin. This works because the camera is factory calibrated to read light reflecting off human flesh tones (e.g., 18-percent gray). Although this technique may not be as accurate as a gray card, it works pretty well in the field. The palm of the hand, almost universally, can be used to take light readings under any illumination, but compare the palm to the back of the hand, and use the one that gives the best results. People with dark skin get the best results using the palm of the

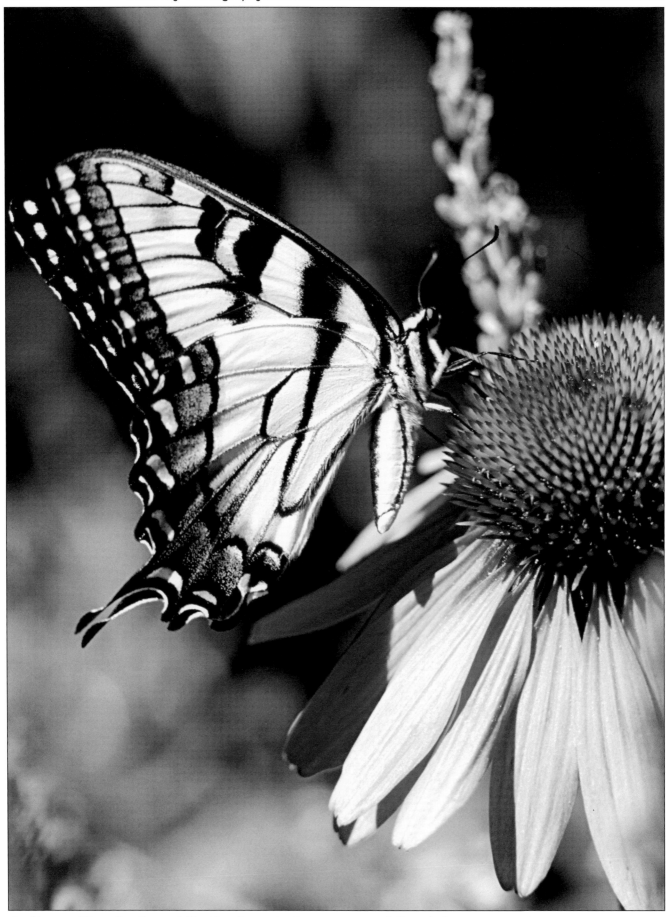

*An Eastern Tiger Swallowtail (Papilio glaucus) taken at noon in full sunlight.*

hand. After taking a few readings (record the test results), it might be necessary to slightly adjust the camera's settings (+/-) to produce consistently good results.

If the subject is in the shade, then the hand must also be in the same shade to obtain an accurate reading. Don't allow a shadow to cross the hand while taking a reading if the subject is in bright sunlight, or the results will be invalid.

• The Rule of Sunny 16

The "rule of sunny 16" is another handy technique. The photographer in the field can quickly and accurately set the camera's settings provided (1) the day is sunny and (2) the film speed is known. If ISO-100 speed film is purchased, then "100" is the nearest shutter speed equivalent. Set the f-stop to f16 and the shutter speed to the "nearest equivalent" (e.g., 1/125th of a second). The results will be consistently good as long as the sun remains bright. Very early or late afternoon shots when the sun is rising or setting will, however, require use of a gray card or a light meter.

The "rule of sunny 16" allows butterfly photographers to pre-set the camera aperture setting to f16 before leaving home or the car. If using ISO-200 speed film, the camera's shutter speed can be set at 1/250th of a second. This allows the photographer to hand-hold a 200mm lens. ISO-400 speed film permits the shutter speed to be set to 1/500th of a second and can be used with more powerful lenses. If you open the box containing the roll of film, it may include either a sheet of instructions or directions printed on the inside of the box, giving specific settings to use under different lightening conditions. If the butterfly is in the shade, or if a cloud obscures the sun, the "rule of sunny 16" does not work. The rule also does not apply to snow scenes (where butterflies are not likely to be found) or at the beach where there is lots of light reflected off white sands (then the rule is to set the aperture to f22).

## ☐ Working with Light
### *Ambient Light*
• Full sunlight

Natural, full sunlight is the best for butterfly photography. Early morning and late evening light can produce beautiful golden hues that reflect off the wings of butterflies as they bask with their wings spread out. High noon, on the other hand, results in good photographs of butterflies but produces heavy shadows, so that's the time to use a reflector or fill-flash. In most cases, the main source of lighting should resemble natural sunlight (that is, from the top down).

• Clouds and Shade

Ambient light also permits working in the shade or when a cloud passes overhead. Adjustments must be made (decreasing the f-stop from f16 to f8, for example), but the results can be very pleasing. Clouds act as a giant diffuser and harsh shadows melt away, yielding very smooth results. To increase maximum depth-of-field, remove a polarizer and substitute an 81A or 81B warming (or amber) filter.

Uniform cloud cover is a great time to take photographs, possibly assisted with subtle fill-flash. However, when many clouds are passing in front of the sun, it is necessary to take constant readings. Illumination varies dramatically from full sun, to sun partially hidden by a cloud, to

"Natural, full sunlight is the best for butterfly photography."

*A Monarch (Danaus plexippus) feeding on teasel (Dipsacus sylvestris) in the shade of a tree. Note the bright sunlight behind the butterfly.*

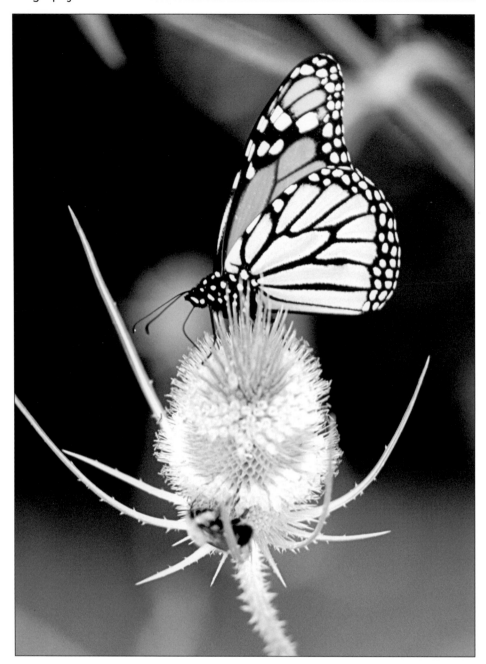

the sun completely obscured by a cloud.

Diffused light can also be obtained in strong, direct sun by holding a white umbrella over the subject. These are usually sold in photography stores for use with strobes, but they serve as excellent diffusers. If too much sunlight is causing heavy shadows, an assistant can open the umbrella and a reading taken in the area under the umbrella using a gray card or hand. Since butterflies don't like

sudden shadows, the umbrella should be moved slowly and as high as possible over the subject. This might be the time to select one or two flowers to work with, placing the umbrella on a tripod and waiting for the butterflies to fly into the shaded area. Photographs in a shaded area (especially with white, diffused lighting) can produce very pleasing results. This is one technique that all butterfly photographers should try.

• Dappled Sunlight

Some of the most complex photography is in dappled sunlight. It is very difficult to obtain a proper light reading, because of the significant difference in illumination between full sunlight and shade (e.g., f16 vs f8). If there is more shade than sunlight, it is possible to take a reading in the shade and allow the area in full sunlight to be overexposed. However, that generally produces a "burned" area in the photographs that is not particularly attractive. Bracketing is a possibility, but there is no guarantee of success. The solution is to use a flash, fill-flash or a reflector.

## Flash Photography

Butterflies also live in woodlands, fly about when lighting conditions are marginal, and feed amid shaded foliage. Strong sunlight may produce heavy shadows that mute the beauty of the wings. In all these cases, a flash unit is vital. Flash can produce stunning results, bringing out hidden details of the butterfly that might otherwise be lost.

The best flash results are obtained with one major source of light (usually the sun or a flash unit) or two side flash units firing at a 45 degree angle to the subject. It is possible to purchase two small flash units, a "slave" unit, and two extenders that can be attached to the bottom of the camera. One flash is attached to the left side of the camera and plugged into the camera's flash sync – this becomes the "hot" flash (the one that fires when the camera's button is pressed). The second flash is placed on top of the slave unit and

*This Red-banded Hairstreak (Calycopis cecrops) was feeding under a leaf. The flowers around the hairstreak were all bathed in full sun. It required fill-flash to make this picture work.*

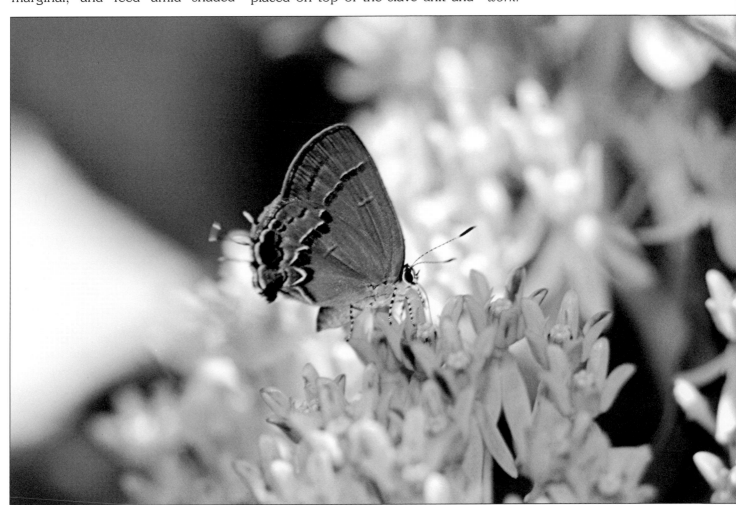

automatically fires when it detects a sudden burst of bright light. That slave unit is attached to the second arm, which extends out from the right side of the camera. The arms are tightened until they face towards the front of the lens.

Ideally, the light from the two flash units should be as close to the ambient light as possible. Only a tiny bit of fill-flash is needed to illuminate shadows but not to overpower the image. The object is simply to highlight shaded areas. White cloth or tissue can be taped over the front of the flash or the arms can be swung away from the front of the lens to lessen the output of the two flash units. A hand-held light meter allows for very accurate measurements, which can be applied in the field. Many cameras using modern TTL metering automatically adjust the output of the flash to the distance of the subject.

Another tip is to set the flash so that it sends out a broad beam of light instead of a narrow one. Many flash units allow the photographer to select a narrow beam for a telephoto lens or a wide beam for a wide-angle lens. But, by selecting a wide beam with a telephoto lens, the burst of light covers a wider area and produces softer shadows.

A problem likely to be encountered is that flash units produce shadows of their own. This can be partially offset by using a diffuser on the flash (many flash units come with a diffuser, or white cloth or tissue can be placed in front of the flash unit). The instruction manual should be consulted, however, as some units generate a lot of heat and flammable materials cannot be placed over the flash head.

*A Bogan Macro Bracket Flash with two Osram flash units. The flash on the left side of the camera is wired to the camera's flash ring. The other flash is mounted on a slave that automatically fires when the first flash goes off. Several layers of tissue are taped to each flash to help diffuse the output of the units.*

It is worth field testing flash units with and without a diffuser. White cloth or tissue taped to the front of a flash unit can give a very pleasing effect by lessening shadows. A variety of tests should be run using different speed film and lenses. The camera's settings should first be preset to the prevailing sunlight and a photograph made of foliage where heavy shadows prevail. A second photograph should be made using one flash unit and a third using both flash units. Each series of photographs should be taken at different aperture settings (e.g., from f11 to f16). Repeat the process using a diffuser and again using a white cloth in front of the flash unit.

Carefully record the settings used to take each photograph, since that allows adjustments in the future. Typically, if the subject is less than a foot away, an "extra" f-stop (e.g., from f16 to f22) might be possible when using two small flash units. If the subject is a foot or more away, then changes to the aperture settings might not be possible using two small flash units, but a subtle degree of lighting will be seen in the in the shaded area. This could be an ideal situation! It is difficult to predict the outcome of different camera systems because the output of light varies between flash units and because output is influenced by use of different diffusers, white cloth, or tissue. Careful experimentation with good notes helps the photographer understand how to produce the best results using his or her equipment.

In low light situations, the use of a side- or top-mounted heavy-duty flash may be required. Modern TTL metering systems are designed to give the best results for subjects taken at a specific distance from the camera. The problem with large flash units, however, is that they can produce unwanted shadows if a stray leaf lies between the flash and the butterfly. Also, the background may sometimes go completely black because of rapid light fall-off. Some of the problems associated with using flash units in butterfly photography are covered in Chapter 5, on photographic techniques.

### Using a Reflector

Butterfly photographers should consider acquiring a small or medium-sized reflector. Photo dealers usually carry a variety of these circular devices that pop out to about four times the size of its pouch. The reflector is gold on one side and white or silver on the other and gives a nice, warm glow, illuminating hidden spaces and shadows. It is very effective if an assistant is available to hold the reflector and aim it at the butterfly. If an assistant is not available, prop the reflector on the ground or against a plant to "warm-glow" the butterfly. The objective, as with fill-flash, is to reduce shadows and bring a little extra light into dark areas. Remember, however, that natural light comes from above and the human eye does not accept natural images where too much light comes from below.

The photograph of the Question Mark (*Polygonia interrogationis*) on the next page was taken in natural light supplemented with a reflector. This individual was in summer color (a golden-brown), resting with its wings open. The Question Mark was already nicely illuminated, but the gold reflector enhanced its beauty by perfectly outlining the edges of the wings. This butterfly almost appears to be floating, except for the leaf tip at the bottom of the photograph

"… consider acquiring a small or medium-sized reflector."

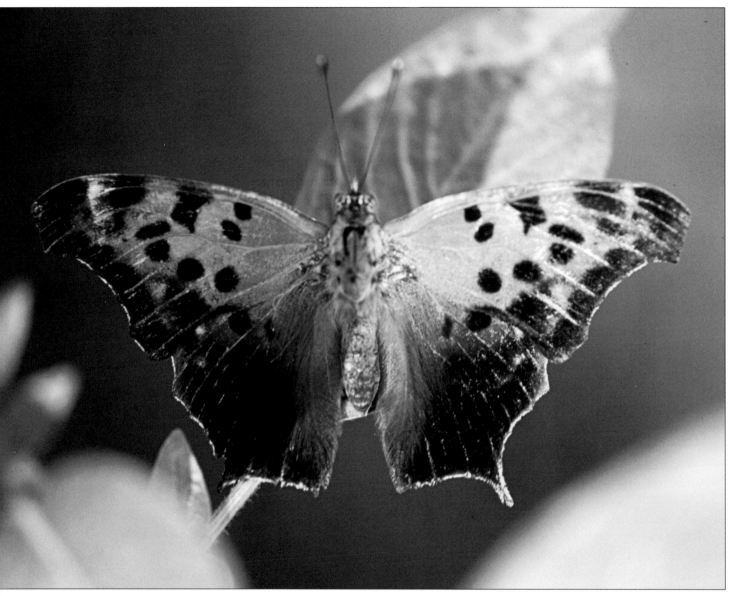

*A Question Mark (Polygonia interrogationis) illuminated from beneath with a gold reflector.*

which shows it is seated and caused a shadow on the left wing. Hairs on the area near the thorax are clearly visible as a result of the reflector.

### Using an Umbrella or Scrim
A white umbrella or a "scrim" (a translucent cloth or thin sheet of white plastic) can be used to soften the effect of strong, overhead sunlight and produce wonderful images. Both allow sunlight to filter through and cast a soft shadow over the subject.

Sometimes a butterfly simply will not tolerate a shadow and using an umbrella or scrim to illuminate the scene with the help of a flash may solve this problem. Either can also be used to "bounce" light up into a subject or down on it for more even lighting. A flash can also be fired directly through a large translucent scrim for the same purpose. A helper is usually needed to hold large scrims or umbrellas.

Many flash units come equipped with a clear or white, plastic diffuser that fits over the front of the flash head. Photographers can also buy diffusers that attach with Velcro straps to the front of a flash unit. The larger the diffuser, the more even the illumination.

The Carolina Satyr (Hermeuptchia sosybius) lives on grasses and sedges. It lives mostly in woodlands from Virginia south to Texas, but some strays have been found as far north as New Jersey. It is easily confused with the Little Wood Satyr that is slightly larger with more conspicuous eyespots. It is in the subfamily of Satyrs and Wood Nymphs. The Carolina Satyr lives in woodlands and especially where pine trees flourish, but can also be found around shady meadows. It is one of the smallest Satyrs and likes standing water, shade, and grasses.

This individual was photographed in South Carolina early one morning well after the sun had burned off all the morning dew. In taking this picture, it was necessary to get fairly close to the ground. When lying on your stomach, use your elbows as tripods or a bean bag to hold the camera steady.

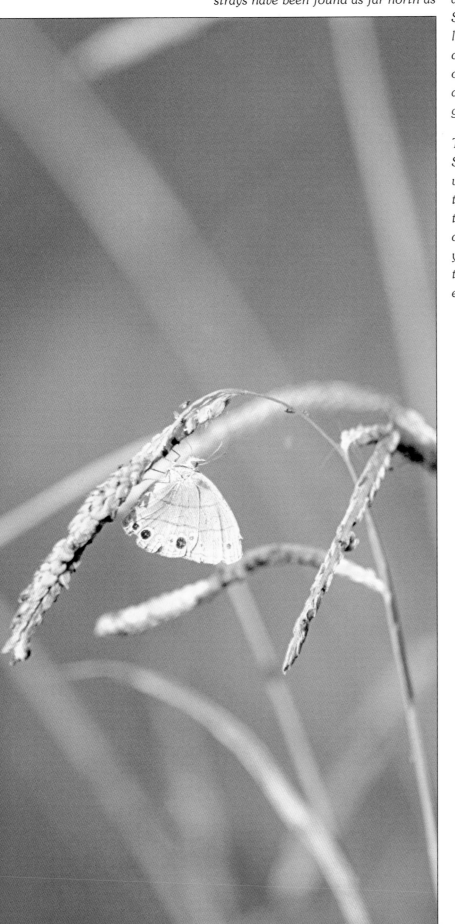

Camera: Nikon FM2
Lens: 80-200mm
Shutter speed: 1/125
Aperture: f11
Polarizer: No
Flash: No
Film: ISO-100
Tripod: No
Hand-held: Yes

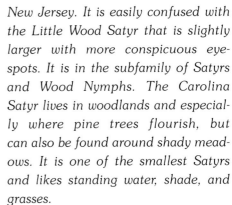

The beauty of the Dahlia (Barbarry Dominion) and the two skippers help make this an attractive photograph. The Yellowpatch (Polites peckins) on the left is one of the most commonly found skippers in North America and its range is expanding. The Sachem on the lower right (Atalopedes campestris) is found mostly in the southern part of the United States. Both species use grasses as their host plants and these are found primarily in fields or meadows. These two skippers were feeding in the formal gardens of Meadowlark Gardens in Vienna, Virginia close to noon in natural light, when shadows were fairly strong. A reflector or a small flash unit would have given more definition to the butterflies, which appear slightly underexposed.

| | |
|---|---|
| Camera: | Nikon FM2 |
| Lens: | 80-200mm |
| Shutter speed: | 1/125 |
| Aperture: | f11 |
| Polarizer: | Yes |
| Flash: | No |
| Film: | ISO-100 |
| Tripod: | No |
| Hand-held: | Yes |

The Little Glassywing (Pompeius verna) is a dark brown Grass Skipper with glassy white spots on its wing. It is very similar to the Dun Skipper (which lacks the white spots on its wings). This species lives in damp woods, clearings, hedgerows, and old fields and range from New England to Texas and east to Nebraska. The host plants for the Little Glassywing is desert bunchgrass (Tridens flavus).

This is an example of how a dark background can help make the subject really stand out. The specimen is clean and crisp and although the background appears black, it is actually a wooded area in deep shadow; the pho-tograph was not taken with a flash. In many cases, a flash fall-off will render the background black.

Camera: Nikon FM2
Lens: 80-200mm
Shutter speed: 1/125
Aperture: f8
Polarizer: Yes
Flash: No
Film: ISO-100
Tripod: No
Hand-held: Yes

The Sachem (Atalopedes campestris), one of the Grass Skippers, favors grasses and ranges from Brazil up to North Dakota, although it is mostly a tropical butterfly. Its habitat includes open areas, landfills, lawns, rural fields and pastures, and it can be found along the side of roads. This Skipper was photographed in a formal garden at Meadowlark Gardens seated on a "Vivid Wild Peony."

This photograph of was taken after a "How to Photograph Butterflies" lecture. The students were taken to the herb gardens, alive with skippers. Typically, most of the skippers in the area were chasing each other and moving quickly from flower to flower. Then we found this Sachem who posed for nearly ten minutes as every class member was able to snap as many pictures as desired. The deep red peony added a bright contrast to the tawny-orange butterfly. The Sachem was still there after most of the class wandered off to find other butterflies to photograph; Sachems can sometimes be very easy to photograph.

The image shows the 'rule of thirds' at work since the Sachem is located in the upper part of the image and not in the center of the photograph. The eye is attracted both to the center swirl of the flower and to the butterfly.

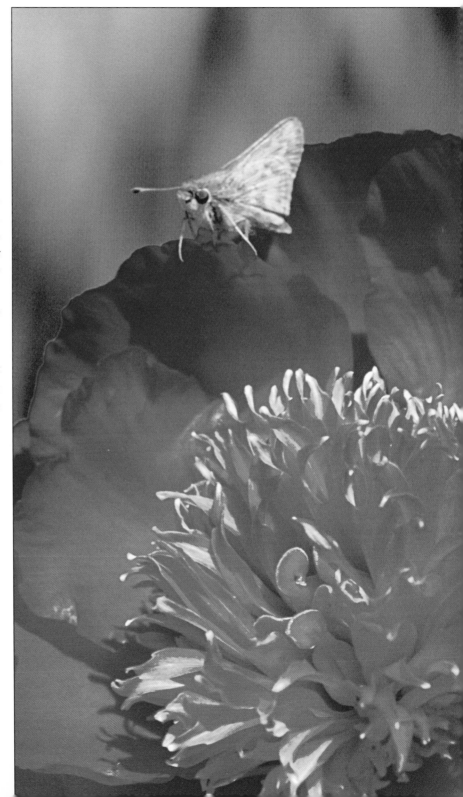

```
         Camera: Nikon FM2
           Lens: 80-200mm
  Shutter speed: 1/125
       Aperture: f8 (bracketed)
      Polarizer: Yes
          Flash: No
           Film: ISO-100
         Tripod: No
      Hand-held: Yes
```

## Putting it All Together

Now let's look at how an understanding of proper light leads to a good butterfly image. If the butterfly is moving about rapidly, the photographer may use a high shutter speed and an f-stop that admits more light. If the butterfly lands in the shade, the photographer may switch to a slower shutter speed and a higher f-stop. A reflector or fill-flash may be used for greater depth-of-field and bracketing ensures one or two really good images. If the butterfly allows the photographer to take more than a couple of photographs, this permits a quick light reading off the palm of the hand or a gray card and, if necessary, time to make adjustments. For another butterfly sitting at a 90 degree angle to the sun, the photographer can put on a polarizer, drop down two f-stops and shoot some more pictures, bracketing up or down slightly depending if the butterfly is light or dark. Does all this work better than the camera set on fully automatic? Absolutely – that's exactly how many professionals operate.

Despite a lot of experience in photographing butterflies, the author still discards many images after each outing. Problems with focusing, blurring, unwanted shadows, etc. all contribute to the rejection of an image. Solution? Take lots of photographs and don't be discouraged. With time and experience, the number of "keepers" will increase.

*A perfect image of an Eastern Tiger Swallowtail (Papilio glaucus): strong, overhead sunlight with a flash to illuminate the underside of the butterfly, no harsh shadows, strong tones, and a smooth, visible background despite the use of flash.*

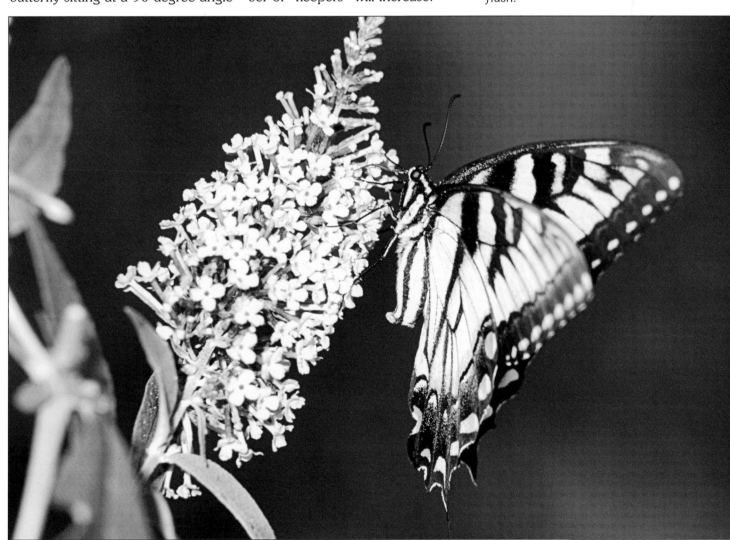

# Photographic Tips and Techniques 5

This section offers photographic techniques – some more complicated than others – for producing visually exciting, sharp, and properly illuminated butterfly images. The only rule is that there are no rules; success or failure is measured by each individual's criteria. One should never lose the sense of adventure or willingness to experiment.

*In this photograph of a beautiful Malachite (Siproeta stelenes), the black plastic container in the background ruined the image.*

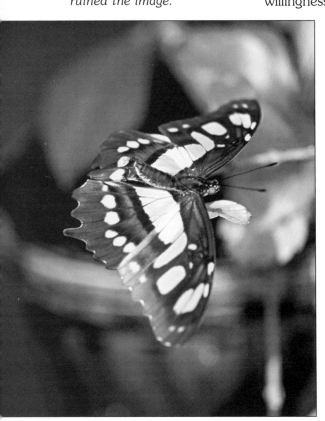

## ☐ The Setting
### *Backgrounds*
Unfortunately, objects in the background have a way of spoiling a picture, so try to avoid unnecessary or objectionable backgrounds. White objects, in particular, can be distracting and even small piece of paper in the background can result in a ruined picture. The solution is to select the lowest aperture and the highest shutter speed (e.g., f2 at 1/500th or 1/1000th of a second). This will blur the background, but it might also blur part of the subject.

Thus, reduce the shutter speed to 1/250th or 1/500th of a second and try at the next highest aperture setting. Then reduce the shutter speed and increase the aperture again. One of these settings should work.

A telephoto lens can be used to blur unsightly backgrounds. Some of the best photographs in this book were made with a 600mm lens set on a tripod, with two extenders between the camera and the lens. This is one of the times when a tripod is a necessity.

Soft muted background colors also help the butterfly shown on page 67 stand out. The optics of many 600mm lenses are so exact that only a tiny zone is in focus – the foreground petals are slightly out of focus while the butterfly is completely in focus. What appears to be a beautiful blue sky is, in fact, an old pickup truck.

There are times when a dark background can attractively set off the butterfly. The butterfly stands out sharply even though it would proba-

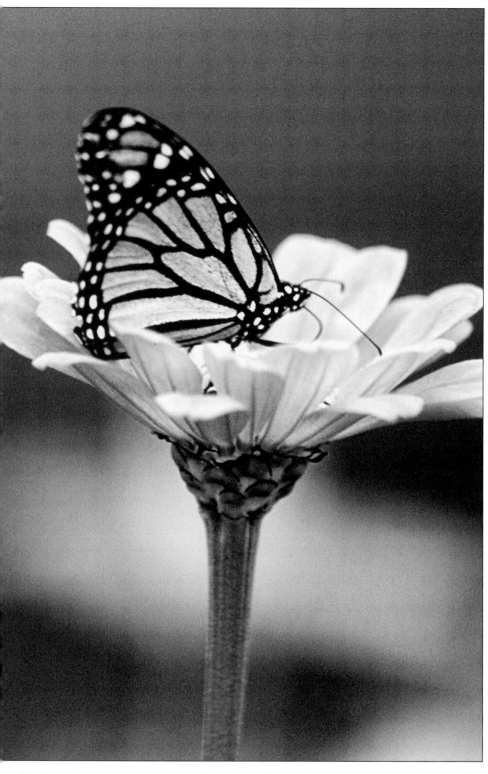

*A Monarch (Danaus plexippus) feeding in front of an old blue pickup truck. The 600mm lens with an extender blurs the background nicely.*

bly have been just as sharp if bright flowers or leaves had surrounded it.

The Sleepy Orange (Eurema nicippe) shown on the next page was photographed without a flash – note the absence of any shadows on the leaf behind the butterfly. The dark shadow in the background allows this image to stand out. The same effect can, of course, be gained with the use of a flash, but that might generate a harsh shadow against the leaf.

## Foregrounds

The foreground is important too. A leaf, a twig, a stem of a plant, or a

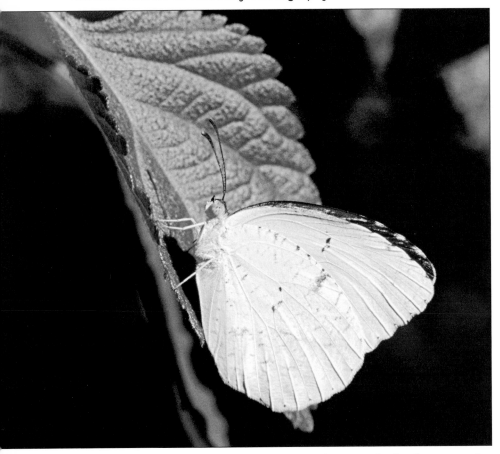

*An effective background can enhance a photograph. In this case, the Sleepy Orange (Eurema nicippe) was photographed against a shadow in the background.*

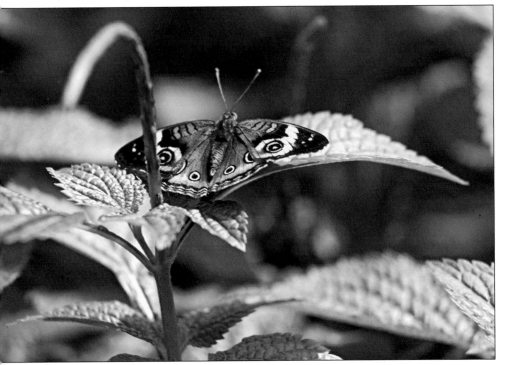

*The tip of the plant crosses in front of the Buckeye (Junonia coenia) and is blurred. The eye does not accept this foreground "intrusion" although the butterfly is in focus.*

dead flower can be distracting as the object becomes blurred. Somehow, the eye is forgiving of items gradually going out of focus in the background, but not as accepting of blurred objects in the foreground.

### Backlighting

Photographers love to have the sun at their back, shining directly on the subject. This provides maximum, direct illumination. However, for every butterfly facing the sun, there will be many facing sideways or with their own backs to the sun. But these, too, can make nice images. Try photographing when the butterfly is illuminated from behind (this is called backlighting), but don't shoot directly into the sun as that may damage the camera's metering system.

Some beautiful details may result from this approach, which was used to photograph a Mimic or Blue Moon (*Hypolimnes misippus*) shown on page 69. The first photograph is a very "traditional" photograph and because the Mimic is mostly black, a little extra light was allowed reach the film by slightly adjusting down the f-stop. Note the shadow; the sun was behind the butterfly, but high in the sky.

Shortly after the first photograph was taken, another Mimic was seen perching with sunlight filtering through the white oval rings on its wings. The resulting image is rather unique. It was photographed with the same settings used to photograph the first Mimic, but because the underside was dark, the photograph turned out underexposed.

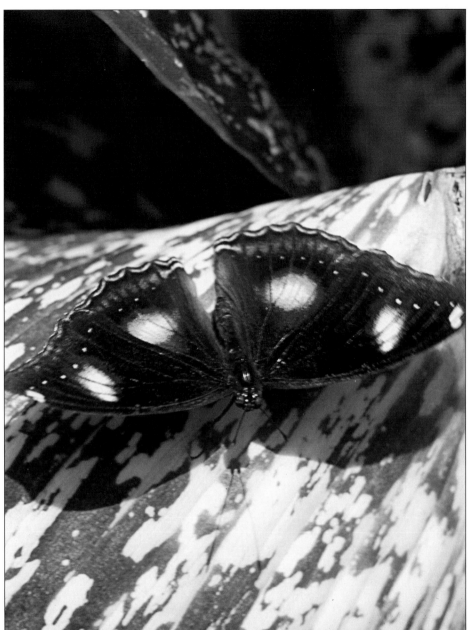

A Mimic (Hypolimnes misippus) photographed first in full light (top), and then using backlighting (bottom). To improve the second image, a fill-flash or reflector could have illuminated the underside of the butterfly, which is slightly underexposed.

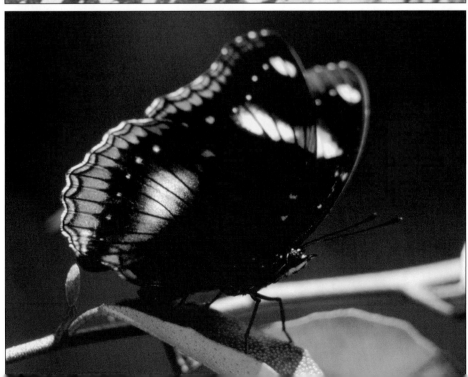

69

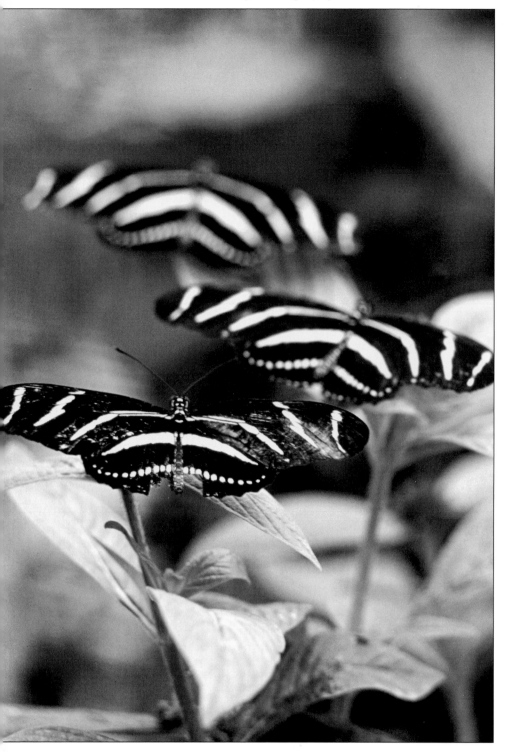

*A group of Zebra Longwings (Heliconius charitonius) shows the repeating patterns of black and yellow bands on their wings.*

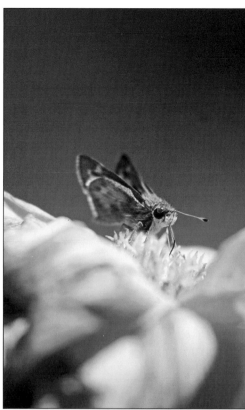

*The flower is used to good advantage here in this picture of a Sachem (Atalopedes campestris). The colors combine nicely to highlight the butterfly. The eyes are sharp, but other parts of the photograph are out of focus to varying degrees.*

### Repeated Patterns

Repeated patterns in nature make for an interesting photograph. Look for several members of the same species to assemble together. Zebra Longwings (*Haliconius charitonius*), for example, roost at night in communities and sometimes gather in daytime, in contrast to species that lead more isolated lives. It was easy to photograph the depicted group of Longwings in Florida, where they live year-round. The resulting repetition of the wing bands makes for an interesting image.

### Foliage

A clump of flowers with butterflies flitting from one blossom to another offers great possibilities, even if it means getting down on both knees to shoot through the flowers. Some of the flowers in the foreground may be blurred and should normally be avoided, but producing a pleasing picture is what counts. Sometimes a dazzling blur of color leading to a butterfly can be a great picture.

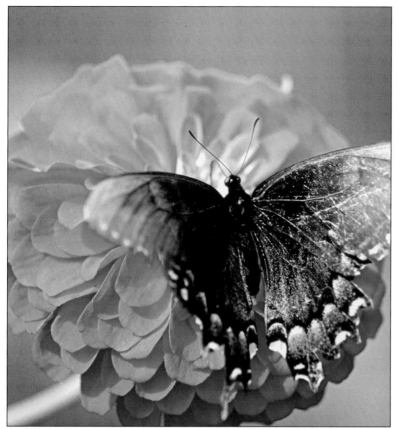

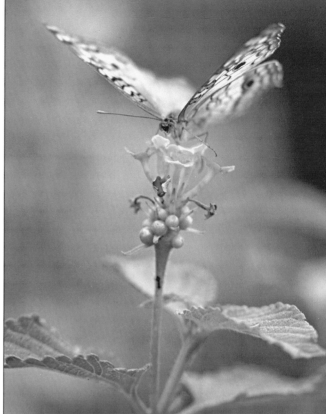

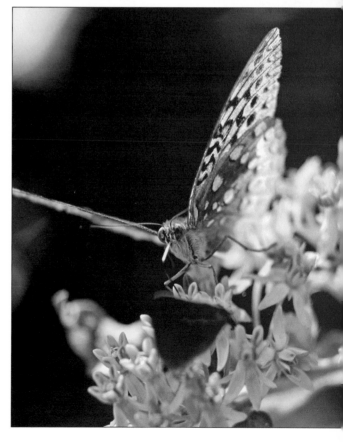

*A slight change in angle can produce quite different results. Note the tight focus on the eyes, and the area of each butterfly that is out of focus. Depth-of-field is very narrow in close-up photography. The butterflies are: Eastern Tiger Swallowtail (Papilio glaucus furnus, top left), White Peacock (Anartia jatrophae, top right) and Aphrodite (Speyeria aphrodite, bottom right)*

## ☐ Winning Images
### *Closing in on the Butterfly*

When approaching a butterfly for the first time, take the first photograph as soon as possible, just in case it flutters off. Then quickly step forward a few paces and take another. If the butterfly remains still, you can move in as close as the butterfly and the camera system allow. Very few butterflies remain still for long, so it's important to move slowly but decisively. Many photographers are initially reluctant to get close, fearing they will frighten this beautiful little creature away and many times that happens. Be patient, because butterflies quickly resume their normal behavior after only a few moments.

Just about everyone takes pictures of butterflies while standing with the camera pointed down at an angle. One out of ten photographers, however, will kneel and shoot upwards at the subject, and that's what sets a good photographer apart from the crowd.

Close-ups are important whether shooting at an angle only slightly higher than the butterfly, or approaching head-on or slightly below. Look at each of the three following photographs

for different perspectives, and try them all.

Keeping the butterfly's eyes in focus may be one of the simplest tips to assist butterfly photographers, but it's often the hardest to follow because the eyes of a butterfly are so tiny! Years of photographing butterflies have proven to me that when the eyes are out of focus, the image generally appears lifeless. Two examples are shown, with the butterflies in sharp focus, but in one photo the eyes are in focus, while they are out of focus in the other.

Unfortunately, keeping the butterfly's eyes in focus is a difficult task. The shutter must be snapped at exactly the right fraction of a second, and little latitude is allowable. This is why a high f-stop (f16 or f22) is so important.

One effective technique for photographing the eye is a very gentle rocking motion (see "Holding the Camera Steady," below). First, preset both the lens to the closest setting possible and slowly lean backward and forward, carefully watching through the viewfinder for the eyes as the butterfly moves in and out of focus. Click the shutter when the eyes are in focus – keen eyesight and quick reflexes are needed. It may be necessary to anticipate when to press the shutter, because there is a tiny gap between the time the

*The eyes of the Great Spangled Fritillary (Speyeria cybele) on the left are completely out of focus, but the wing is in focus. The image appears lifeless when compared with the Julia (Dryas iulia) shown on the right, where the eyes are in focus.*

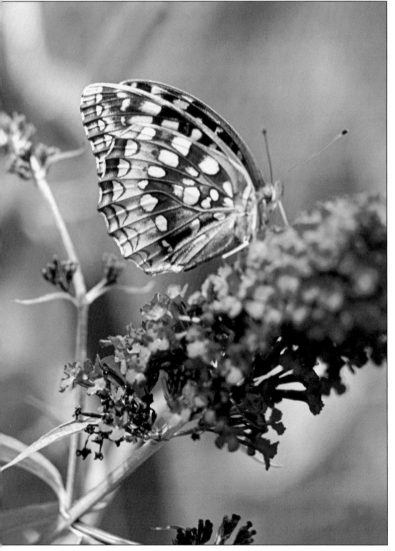

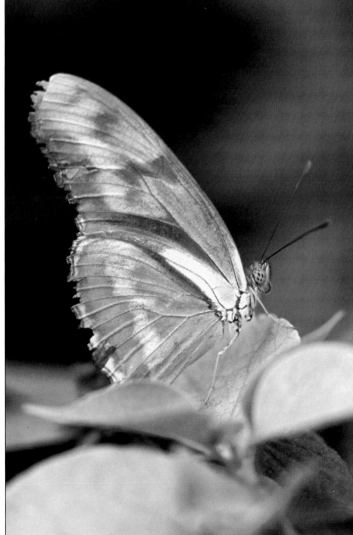

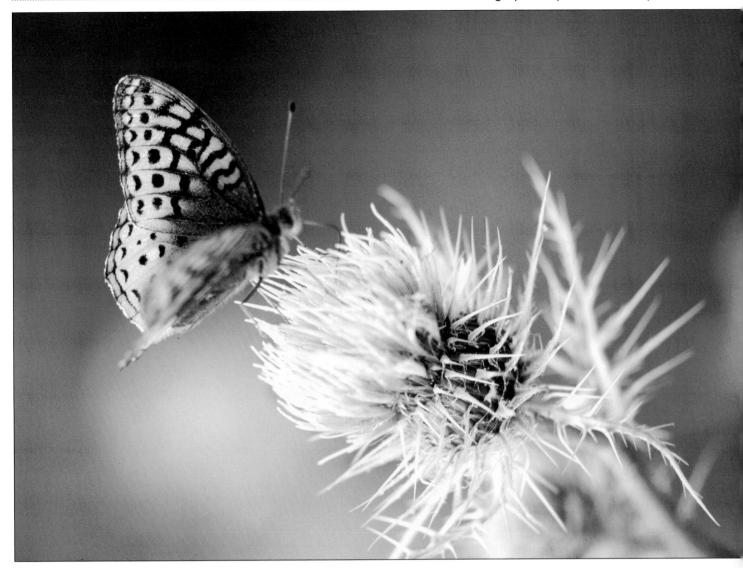

brain sees the eye as "in focus" and when the finger presses the shutter release. This delay may only be a few thousands of a second, but because the eye of a butterfly is so small, only miniscule distances are needed for the subject to be in or out of focus. Expect to toss out a few images because the eyes aren't in focus; the photographer willing to sacrifice some film will, however, come away with some good images. And keep trying, it takes practice.

But there are instances where eye sharpness isn't necessary. The accompanying image of a Great Spangled Fritillary (*Speyeria cybele*) feeding on a thistle displays the butterfly's back wing in clear focus,

whereas the head is out of focus. The picture is acceptable, through, because the wing is so sharp against the soft, sage-green background. The viewer's eye seems to accept both the thistle and back wing as the focal point of the photograph, and the head and front wing – although out of focus – of minimal importance.

### Fine Focusing

Butterflies range in size from less than an inch to those over six inches. If the butterfly is facing sideways, it's fairly easy to come away with a sharp image. If diagonal, however, it's harder. Fine focus is especially needed when focusing on the eyes. Expect that some parts of the but-

*The eye of this Great Spangled Fritillary (Speyeria cybele) feeding on a thistle is out of focus, but it does not seem lifeless.*

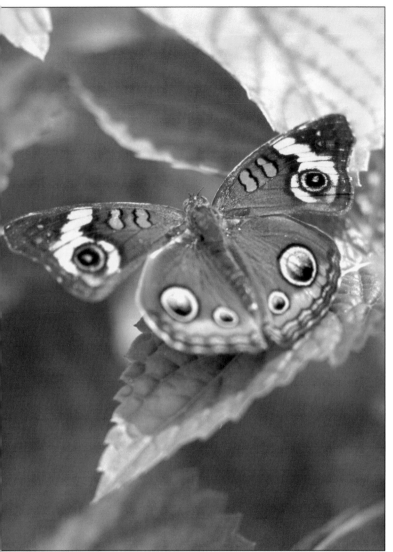

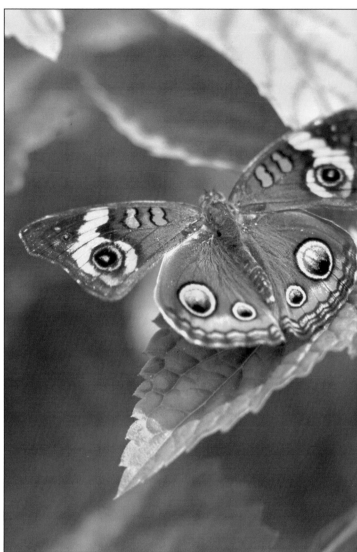

*The image of the Buckeye (Junonia coenia) on the left is slightly out of focus, although the head area is in focus. The image on the right was taken a second later and the whole butterfly is in focus. Why? Either because I bracketed upwards slightly (e.g., went from an aperture setting of f16 to f17) or more likely because I was exactly in the right place in my rocking movement when the shutter snapped.*

terfly to be out of focus and accept the fact that some photographs may be poor. The alternatives include use of a tripod or monopod, flash, fill-flash, or a reflector and bracketing to higher aperture settings. In some cases, it is just plain luck.

### Holding the Camera Steady

Sharp images require a steady hand, and here's a good technique for holding the camera steady. Place the camera on your left palm while resting the lens on your outstretched fingers as shown on page 75 (tuck your elbow tightly against your ribcage). The right hand can now be used to press the shutter and advance the film. When taking a particularly close shot, take a deep breath and

slowly exhale while leaning gently in and out of the focus area. Keeping the camera pressed firmly to your forehead while looking through the viewfinder reduces camera shake.

Your stance is important, too. Stand as firmly as possible on the left foot as close to the subject as possible. The right foot should be placed two or three feet back and used to gently rock forward and backwards. Many beginners stand with both feet together and bend forward at the waist, but stumble if they tilt too far forward. By careful positioning and holding the camera steady, acceptable images can be taken at 1/125th of a second with a 80-to-200mm zoom lens at maximum

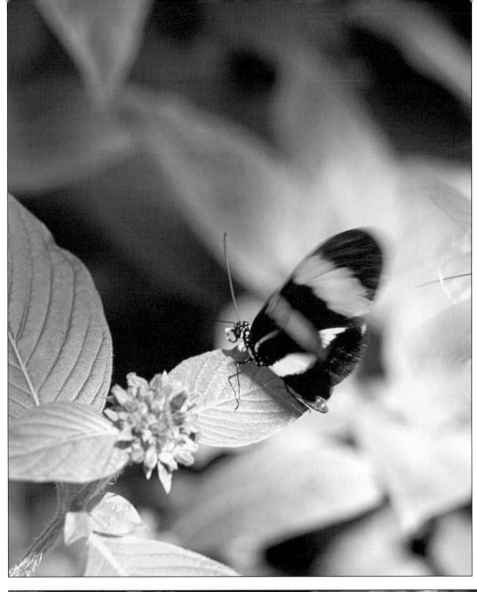

Left: The eye and body of this Rosina (Heliconius rosina) from Costa Rica, appear sharp, but the wings are blurred. The absence of shadows shows that a flash was not used, and because it was taken in the shade, a slow shutter speed was needed. Tripods were not allowed, so this was taken with a hand-held camera.

Below: To hold the camera steady, prefocus as close as possible and lean slowly forwards and backwards holding your breath when snapping the shutter. © Edward J. Pastula, Reflective Imagery, Ltd.- 1999.

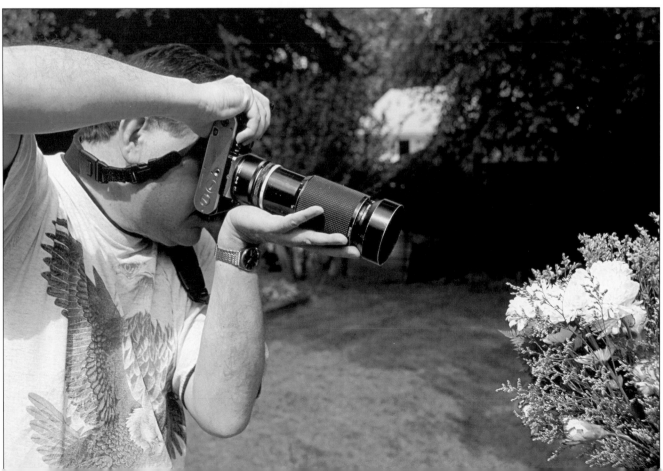

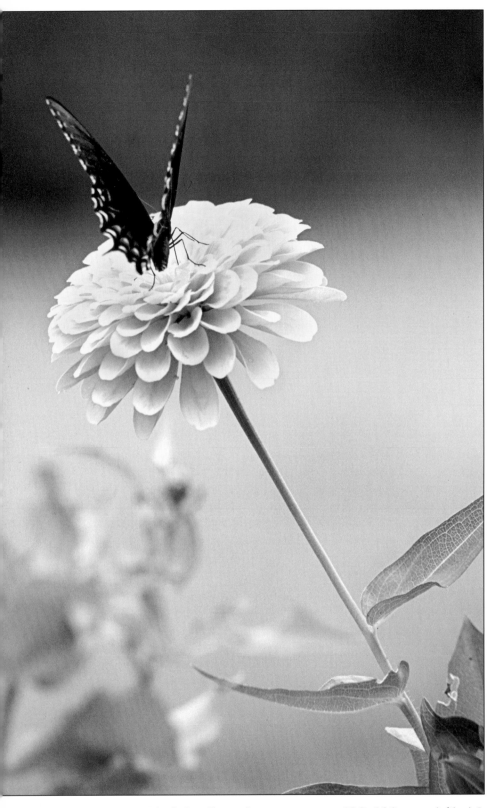

*This Eastern Black Swallowtail (Papilio polyxenes) sits in the top left quadrant of the photograph.*

rosina) seated near the edge of a deeply shaded area in a butterfly conservancy where tripods were not allowed. The camera's shutter speed was set at 1/30th of a second and the aperture was set at f8, using ISO-100 speed film. The butterfly appears sharp, except for the wings which are fluttering. The aperture setting was good and camera shake was minimal, but the shutter speed was too low to stop the motion of the wings. This technique is not recommended as a standard practice, but it served the purpose in this instance.

### Varying the Placement of the Subject

Many photographers place the butterfly directly in the center of the picture frame, and there is nothing wrong with that. However, if time permits, try placing the subject slightly to one side – the best picture shows the butterfly facing an open space. Photograph the subject in the lower left facing right, or in the upper right facing left or vice-versa. Some cameras accept a grid screen marked with a "tic-tac-toe" pattern (#) that divides the view screen into three rows of blocks that helps keep the horizon level (a valuable feature for anyone wearing glasses). The "Rule of Thirds" may help produce visually stronger, more interesting images if the subject is placed where a vertical meets a horizontal line.

### Capturing the Entire Butterfly

Close-ups are wonderful, but it's a good idea to take a few pictures of the entire butterfly to help in its identification. When approaching a butterfly for the first time, take the first photograph as soon as possible, just in case it flutters off. Then carefully step forward a few paces and

power using ISO-100 speed film! It took a lot of practice over many years to perfect this technique.

An example of this technique can be seen in the photograph (previous page) of the Rosina (*Heliconius*

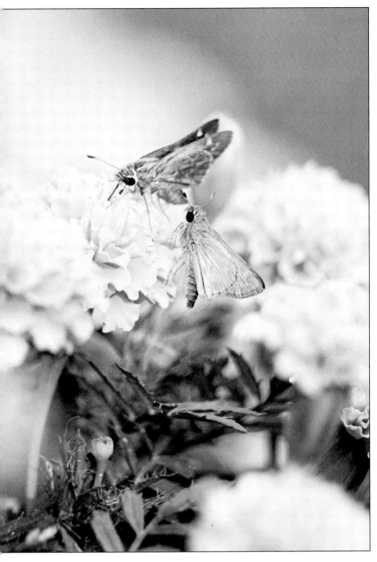

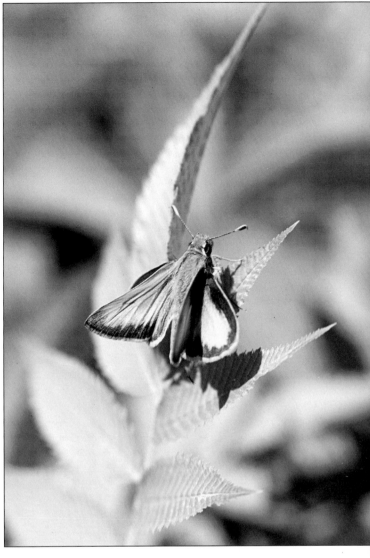

take another series of photographs, capturing both sides of the wing for positive identification. Of course, that can be difficult. If the butterfly remains, move in as close as possible and take close-ups even though some parts of the butterfly may not be visible.

## ☐ The Portfolio
### *Start Off with Something Easy*

You can build your skills best by selecting butterflies that are easy to photograph and make good subjects. Skippers are usually accommodating if you can find one sitting still for more than a few seconds. Males spend most of their time chasing away other males or looking for

females and are quite hard to photograph during this activity. However, they (or others) return repeatedly to feed at the same flower, and when at rest, appear most willing to allow a photographer's approach. Once you've mastered photographing skippers, you'll have more luck in taking pictures of more elusive or skittish butterflies.

### *Include "Common" Species*

For many years the author took pictures of every butterfly in sight, including the bountiful skippers common to Virginia. Then one day I was asked to submit photographs for a book entitled *Butterfly Gardening* published jointly by the Xerces Society and the Smithsonian

*Left: Skippers are usually easy to photograph when at rest; set up in an area and wait for one to return.*

*Right: This Golden Skipper (Poanes taxiles) was the author's first published butterfly picture. Sometimes what's needed will be right under your nose.*

*Left: An Eastern Tailed Blue (Everes comyntas). This tiny silver-blue butterfly is about the size of a dime. It was photographed in the fields of the Manassas Battlefield Park during the July 4th butterfly count. This species is small, but often allows you time to focus and take several pictures.*

*Right: A Gulf Fritillary (Argraulis vanillae) under a poinsettia on Maui, Hawaii. Many butterflies hide under leaves to avoid getting wet in a rain shower or to rest at night without being seen by predators.*

Institution. Of all the many photographs I submitted, the only one selected was the common Golden Skipper (*Poanes taxiles*). Likely it was chosen because nobody else bothered to take pictures of such a "common" butterfly. The lesson here is to photograph even the most common of butterflies along with the rarer species. Don't overlook the obvious – you don't know what will be desired by a publisher, and a good portfolio has some of everything.

## Look on the Ground

Some of the most beautiful butterflies are the diminutive "blues," such as the Spring Azure (*Celastrina lador*) or the Eastern Tailed Blue (*Everes comyntas*); there are many others. These tiny creatures are found living amid blades of grass or on clover, alfalfa, lupines, and other plants close to the ground. Although you'll need to get down flat to photograph some of these little creatures, a few can be extraordinarily patient and allow picture after picture to be taken. Others, alas, wait until just before the shutter is snapped and disappear, leaving the photographer very frustrated. But keep skimming your eyes over the ground – there's great subject matter at your feet!

## Expect the Unexpected

Some of your best shots occur when you're not expecting them, so always keep an eye out for the

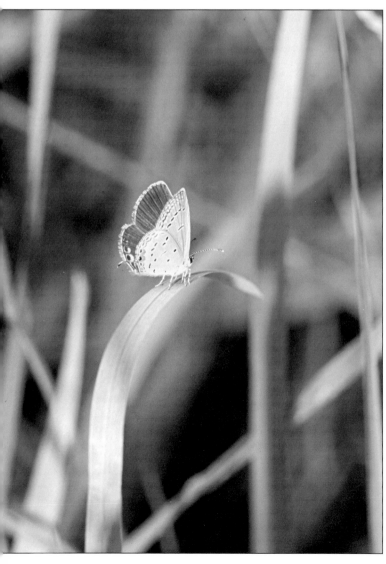

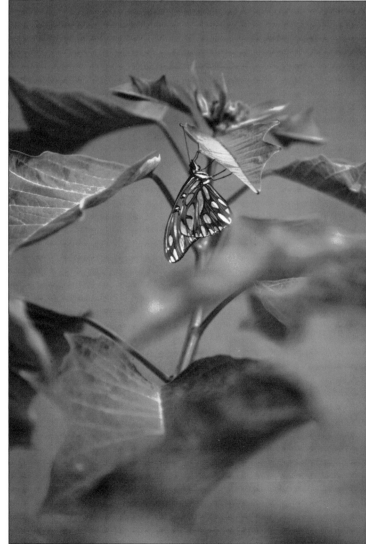

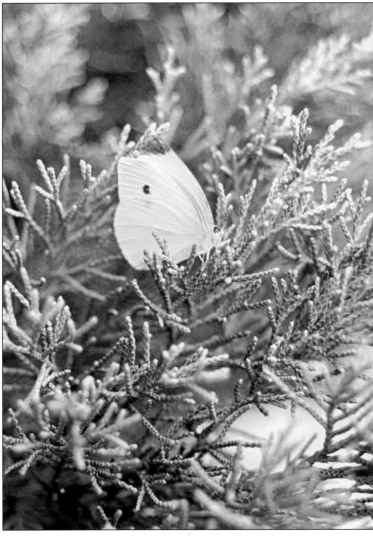

unusual. The Gulf Fritillary (*Argraulis vanillae*) on the previous page was spotted hiding on a poinsettia plant on the island of Maui, in the Hawaiian Islands, thousands of miles from its normal Gulf of Mexico home. This is one of the "exotics" that now are adapted to living in Hawaii. What a delight to spot a species so far from home and to record that fact on film.

### Record the Life Cycle

Just as the daily life of a butterfly can be fascinating, so, too, is its life cycle. The butterfly goes through four completely separate stages of life: egg, caterpillar, pupae, and adult. The nature photographer shouldn't miss opportunities to record this progress.

Part of the life cycle is death, and this, too, affords opportunities for taking photographs of butterfly predators, such as birds and spiders. Butterflies live fairly short lives, sometimes only a few weeks, and are often found dead. Photographing them is this state often doesn't produce a satisfying picture. The photograph of the European Cabbage White (*Artogeia rapae*) shown here simply doesn't look right, because it has died. It's slightly tilted, an unnatural pose in life. It's best to work with living creatures.

### Document the Behavior

Try photographing different activities of butterflies. The more images available in your portfolio about a species of butterfly, the better your

*Left: The caterpillar of the Giant Swallowtail (Heraclides cresphontes) looks like a large bird dropping and will fool many predators.*

*Right: A European Cabbage White (Artogeia rapae) seconds after dying. The pose is clearly unnatural.*

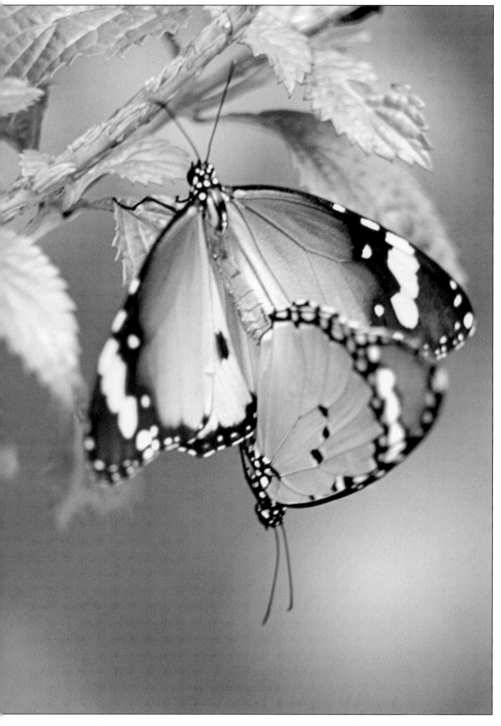

*A breeding pair of Asian Monarchs (Danaus chrysippas).*

eggs, flying, etc. – the whole spectrum of butterfly life.

## Photograph the Habitat

Most conservationists agree that butterflies are slowly losing their habitat. Therefore it's therefore useful, when in the field, to take photographs of the butterfly's habitat. Try to capture the surrounding vegetation, nearby woods or ponds, background hills or beaches, and perhaps the grasses and soil, even though your subject is on a branch overhead. Whether this contributes to better knowledge of butterflies, to an understanding of habitat, or whether it results in a good picture, take the time to take a couple extra pictures. You'll never know when you might be asked to contribute to an article about ecology, conservation, or wildlife management.

## Be Patient

This is not a photographic technique, but it helps to be patient. Butterflies can be frustrating to photograph at times. If you are willing to wait – sometimes for fifteen minutes – they may return to exactly the same spot. Use the time to review all your camera settings. Focus on a nearby subject close to where the butterflies were found when you first appeared. If they don't reappear after fifteen minutes, move on.

chances of having it published. However, try to capture behavior of uncommon species. Photographing Monarchs, although certainly very enjoyable, will result in tremendous competition, while images of a relatively unknown species found only in a small territory are much more likely to result in publication. Your portfolio should have butterflies feeding, drinking, puddling, mating, laying

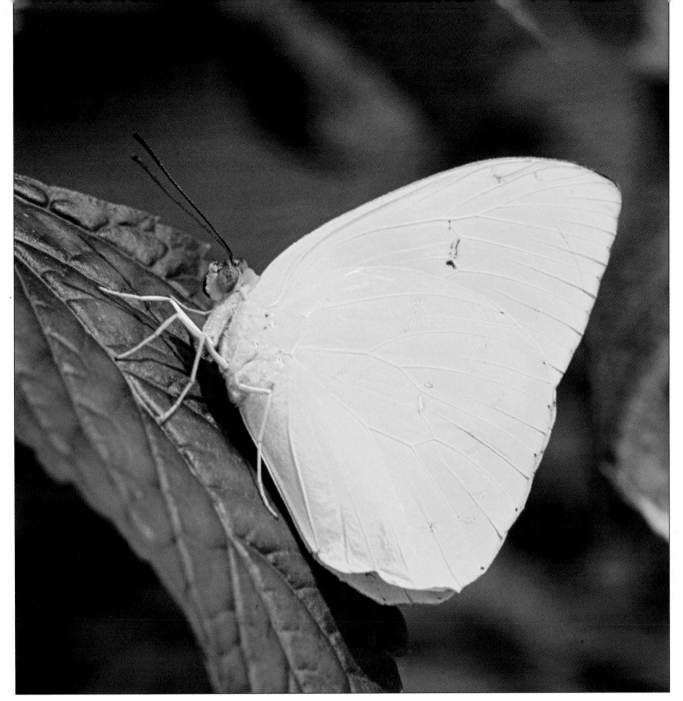

This large, yellow butterfly (the Cloudless Giant Sulphur (Phoebis sennae)) is a member of the Sulphur family. It likes gardens, coastal areas, and waterways and is found mostly in the states bordering the Gulf of Mexico and Southern California. It will sometimes migrate north as far as Canada, although this is not too common.

Unfortunately, many shots of bright yellow or white butterflies simply don't turn out. Thus, it's important to take careful readings of the illumination near the subject using a gray card or your hand – typically f16 at 1/125th of a second using ISO-100 speed film. Then bracket (e.g., from f16 to f19). Some images will be discarded, but many great shots will also result. Don't be concerned about those that are underexposed – look for those that came out perfectly!

Camera: Nikon FM2
Lens: 80-200mm
Shutter speed: 1/125
Aperture: f8 (bracketed to f10)
Polarizer: Yes
Flash: No
Film: ISO-100
Tripod: No
Hand-held: Yes

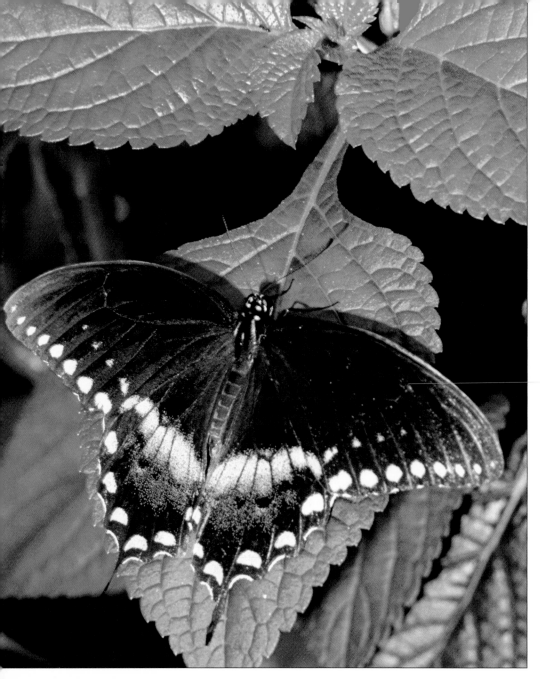

This Spicebush Swallowtail (Papilio troilus) is also known as the "Green-clouded Swallowtail." Its primary host plants include spicebush, sassafras, and different bays and it feeds on Joe-Pye weed, jewelweed and honeysuckle. It lives in woods, along meadows, and in right-of-ways in the northeastern parts of the United States.

It was obvious to me that a flash would be necessary to bring out the area near the thorax of this butterfly. A close look reveals a dark background, proving that a flash was probably used (it was) and that a slow shutter speed was not used to compensate for the flash fall-off. The subtle shadow is another indication that the photograph was taken with a flash. A diffuser, however, was used to reduce the overall shadowing effect and the flash produced nice, even illumination across the wingspan, with minimal specular highlights.

Camera: Nikon FA
Lens: 80-200mm
Shutter speed: 1/250
Aperture: (TTL)
Polarizer: No
Flash: Yes (Metz 450CL-4)
Film: ISO-100
Tripod: No
Hand-held: Yes

One of the best-known of the eastern swallowtails, the Eastern Tiger Swallowtail (Papilio glaucus) ranges from the border with Canada down to the Gulf of Mexico. It lives in woodlands, parks, gardens, and along roads and rivers. It's especially attracted to the butterfly bush and dozens can be found feeding on large, mature plants of this species.

This image was taken with a 600mm lens placed on a tripod with an extender placed between the lens and the camera. The tripod was placed as close to the thistle as possible. An exact ambient light reading was taken (using a hand-held meter in this case). The camera was then set on manual. Since the camera was on a tripod, the shutter speed was set to 1/60th of a second to give the best aperture possible (f16). Then it was simply a question of waiting. Although the background is black, no flash was used.

Camera: Nikon FM2
Lens: 600mm with extender
Shutter speed: 1/60
Aperture: f16
Polarizer: No
Flash: No
Film: ISO-100
Tripod: Yes
Hand-held: No

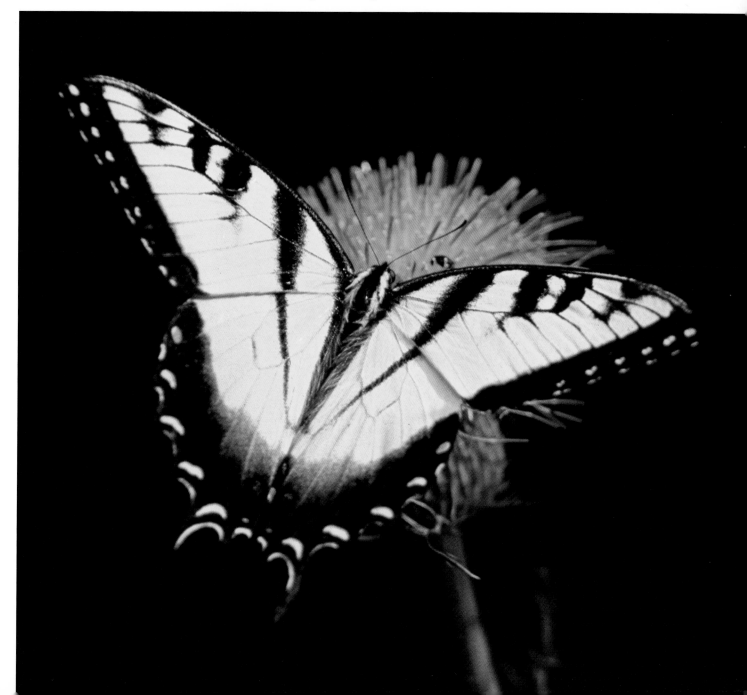

A member of the swallowtail family that ranges from Canada to the Gulf of Mexico and into the Great Plain states, the Zebra Swallowtail (*Eurytides marcellus*) is the only abundant kite swallowtail in the United States. It lives only near the pawpaw tree or relatives of this tree.

This beautiful subject was photographed in Leesylvania State Park, next to the Potomac River near Woodbridge, Virginia. The park has plenty of pawpaw trees and offers a variety of sites that are especially attractive to all types of butterflies, especially the Zebra swallowtail. The photograph is unusual because of the matching color of the spots on the tail and the flowers it's feasting upon.

Camera: Nikon FM2
Lens: 80-200mm with extender
Shutter speed: 1/125
Aperture: f8
Polarizer: Yes
Flash: No
Film: ISO-100
Tripod: No
Hand-held: Yes

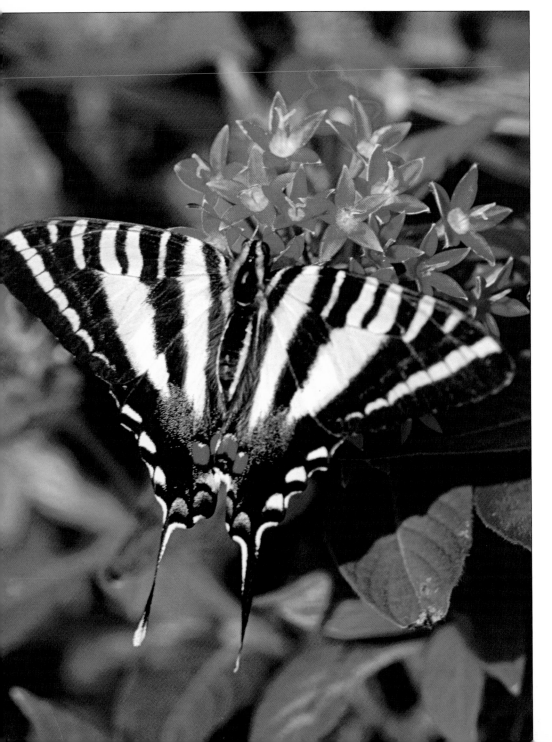

# Overcoming Problems in Butterfly Photography

# 6

Butterfly photography poses specific problems, but they can generally be overcome. This part deals with those situations, allowing the photographer to effectively photograph these elusive, fast-moving, unpredictable creatures.

## ☐ The Problem of Butterfly Movement

The hardest part of butterfly photography is getting butterflies to remain still! And even if they do sit still, butterflies have the uncanny knack of flying away the second before the photographer presses the shutter. So one must carefully develop a strategy that fits into the butterflies' behavior.

### *Preparing to Shoot*

First, install an extension ring(s), multiplier, or a polarizer. Next, take a careful light reading and pre-set the camera's settings. Then pre-focus on one or two flowers where the lighting is good and there are no obstructions. Look over the background and remove dead flowers or pick up odd pieces of paper. Sit down in a comfortable position. Several minutes may have to pass

until the butterflies accept the intrusion and one alights on a nearby flower to resume feeding.

### *The First Shots*

When one does alight, it's best not to move just yet. Watch how long it takes the butterfly to complete its feeding on that flower – two seconds? five? ten? Most probably feed in a circular motion and then flutter off to the next flower for a similar ritual. Before too long, another butterfly lands on one of the flowers close at hand. Based on your observation, you judge that it will take six to ten seconds to complete feeding. Take the first photograph two or three feet from the flower. If the butterfly isn't alarmed and continues to feed, take a step forward and press the shutter. This should now bring you within close range of the subject, and you can begin moving gently in and out, focusing on the eyes and snapping away. Sometimes the butterfly faces away from the camera, sometimes sideways, and then, before you get another shot, will be gone. Sometimes the butterfly leaves in seconds, but sometimes you get

"... develop a strategy that fits into the butterflies' behavior."

*Left: The pear, wasp, and one Red-spotted Purple (Limenitis astyanax) are in focus. Two others however, are badly blurred as they struggle over feeding rights to the nectar of this ripe pear.*

*Right: This Monarch (Danaus plexippus) is properly exposed according to the light metering system in the camera. But notice that the background is completely underexposed, making it appear that it was taken at night. That's great for a Luna Moth, but not for a Monarch.*

lucky and it will stay and feed, allowing ample time for pictures.

## The Best Shots

At this point, carefully review your settings. Are they correct? If there is an error, now is the best time to correct it. Always step back and look over your settings after a series of good shots. Then wait for the next butterfly. This time, carefully bracket your shots, deliberately over- and underexposing just a bit. If the butterfly is quite dark, open up slightly (e.g., go from f16 to f14) or if the butterfly is light in color, then reduce the aperture (e.g., go from f16 to f18). If it's appropriate to add a polarizer, reduce the aperture by two stops (e.g., from f16 down to f8).

Rotate the polarizer's lens to determine which position yields the greatest (or least) amount of saturation. When it's deeply saturated, allow a little extra light to reach the film. If the butterfly is in the shadow, remove the polarizer and use the extra f-stops to boost the depth-of-field.

## Blurred Shots

Blurring typically becomes a problem when a low shutter speed is selected while using a lower rated ISO film, a polarizer, one or more extenders, a multiplier, or when the subject is in the shade. Although the butterfly may be perched, it may well be fluttering its wings, and this causes blurring. The photograph of two

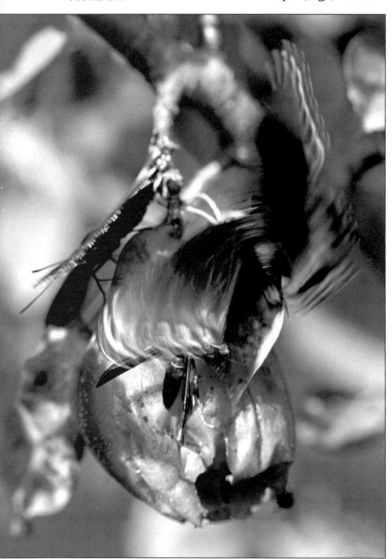

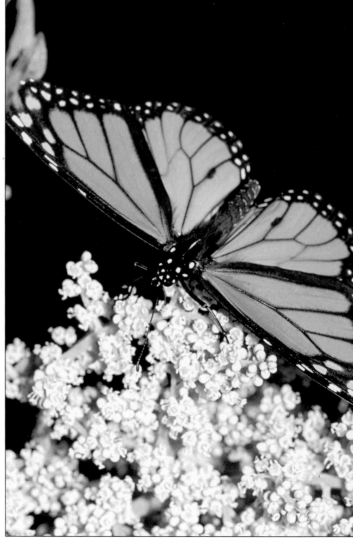

Red-spotted Purple Admirals jostling on a ripe pear is a clear example of blurring. The pear and other insects (a wasp) were in sharp focus (probably photographed between f8 and f11), but the two Admirals were struggling all over the place and their wings were a blur (shutter speed was set at 1/30th of a second). Since a low ISO film was used for this shot taken in the shadow of the tree, there was little else that could be done to avoid slow shutter speeds, except to use fill-flash, a reflector, or a higher rated ISO film.

## ☐ The Problem of Unlit Backgrounds

A flash can yield excellent results when used as a fill-flash. However, many through-the-lens metering systems are manufactured to measure the distance of the subject to the camera and to close the shutter when the subject is fully illuminated, but not objects behind it. This is due to light "fall-off." In some cases, the outcome is unacceptable, and it makes the butterfly appear to be feeding at night. This might be acceptable for moths, which are nocturnal, but not for butterflies that are generally active during the day. If less dramatic effects are sought, consider using fill-flash to help illuminate both the butterfly and the background. There are also other techniques for using the flash to good effect.

### Solution: Trick the Camera

The problem of light fall-off can be solved the "tricking" the camera's flash system. The shutter speed should be set at 1/60th of a second or possibly even 1/30th of a second. This allows ambient light to reach the film and results in a balanced photograph. This technique was used to photograph the Silver-

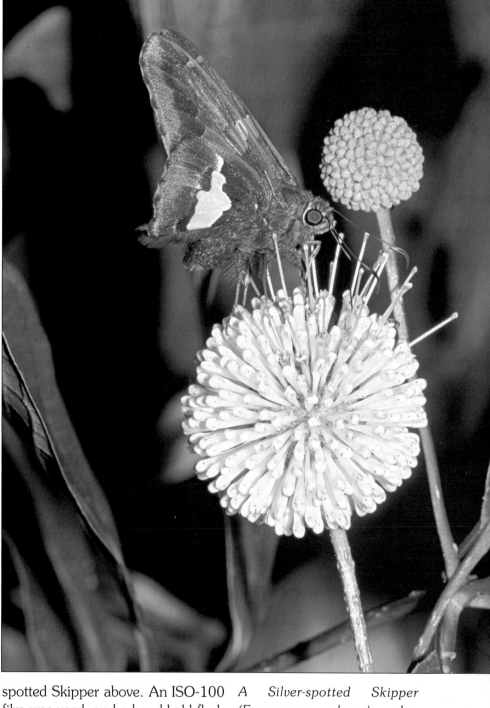

spotted Skipper above. An ISO-100 film was used, and a hand-held flash meter determined that at that distance, the aperture could be set to f22 at 1/125th of a second. In order to have the foliage in the background register on the film plane, the shutter speed was set to 1/30th of a second, well below the suggested speed. The result is a superior image of the skipper, fully illuminat-

*A Silver-spotted Skipper (Epargyreus clarus) photographed in full sunlight with an 80-to-200mm lens with an extender. The camera's metering system was tricked by manually setting the shutter speed to 1/30th instead of 1/125th of a second. The f-stop was set to f22.*

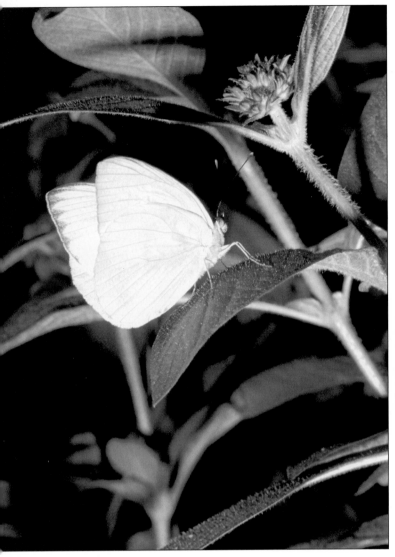

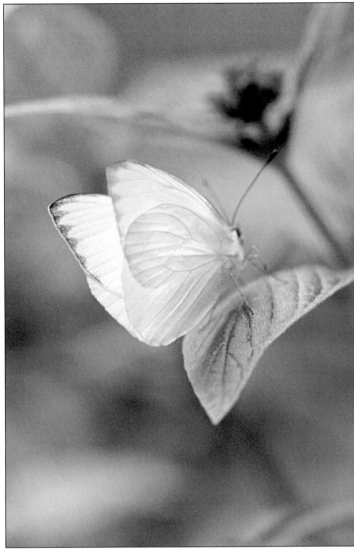

*Compare the Great Southern White (Ascia monuste) photographed with (left) and without (right) a flash. The butterfly is properly illuminated both times. The "diffuser" in the second instance was some fairly heavy clouds overhead. Both images are of the same butterfly in exactly the same place, but notice the soft background that happens when a very low f-stop is selected (probably f4).*

ed, with every detail clear and crisp, and the background foliage shows as well, albeit with some shadowing.

### Solution: Use a Diffuser

A diffuser also allows more of the background to be seen. A diffuser can be something a simple as a white tissue or cloth placed in front of the flash unit, and many flash units come with a built-in diffuser or can be purchased at a modest price. Clouds are also excellent diffusers.

### Solution: Use an Umbrella

The problem of a poorly illuminated background can be solved by using a large white umbrella. These are sold in photography stores for use with strobe units. To use, bounce the

flash up into the umbrella, which reflects a soft, gentle light down onto the butterfly and surrounding foliage.

### Solution: Use a Reflector or a Scrim

A small, portable reflector (gold on one side and silver or white on the other) reflects sunlight into areas in the shade. A white scrim can also help illuminate shady areas. Both are relatively inexpensive ways to highlight and are particularly effective because you can see the results immediately.

### Solution: Use Fill-Flash

Fill-flash adjusted as closely as possible to ambient light can also help

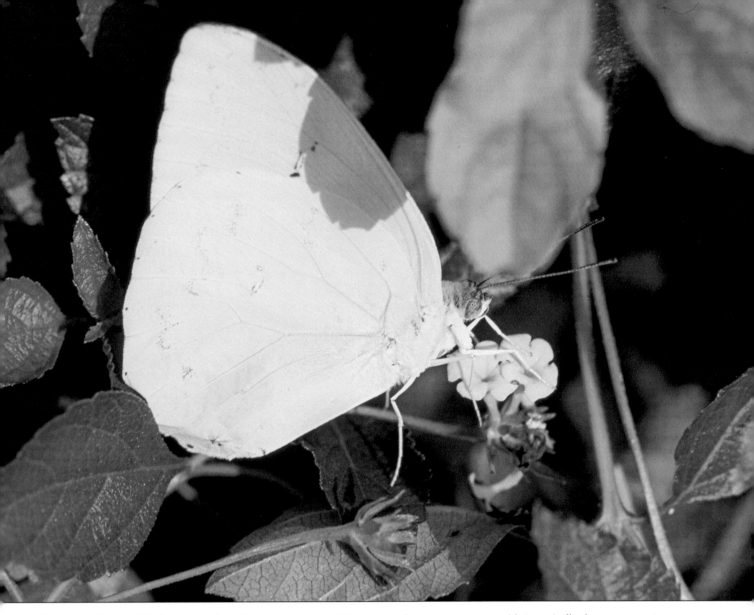

reduce shadows. Fill-flash used with reflectors can be quite effective.

### Solution: Select a Wide Beam

Some flash units allow the photographer to adjust the light output to the type of lens being used (e.g., a wide beam for a wide-angle lens, or a narrow beam for a telephoto). By selecting the wide beam with a telephoto lens, the burst of light covers a wider area and produces softer shadows.

### ☐ Other Lighting Problems
### Shadows

A flash can produce shadows in the wrong places. Usually a leaf or a stem gets between the flash and the subject and casts a shadow over the image, spoiling an otherwise great shot. Solution? Keep an eye on the foreground and either move the object or shoot around it. Frequently, however, the problem won't be manifested until the film comes back from developing.

A flash can also produce unnatural lighting. This happens when a top-mounted flash is turned to the left as the camera is shifted to a vertical position. Usually it's not a problem, but when shooting up, it can result in artificial-looking images. Why? In nature, sunlight shines from above, so a natural subject illuminated from below looks out of place. Best solution? Use a diffuser, a white umbrella, or a reflector.

*Above: A flash can sometimes produce shadows that spoil an image. This is what happened with this Large Orange Sulphur (Phoebis agarithe)*

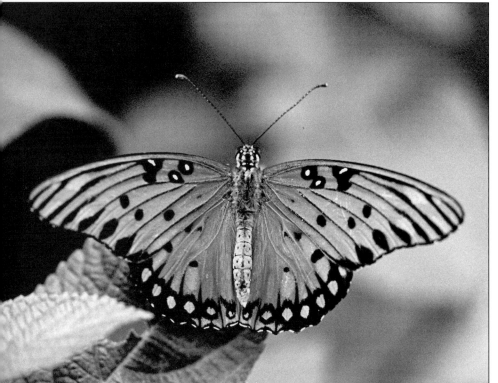

## Specular Highlights

A flash system produces quite a lot of light, especially when used for close-up images. This powerful light highlights the reflective areas, and creates "specular highlights" as shown in the two photographs of the Gulf Fritillary taken with and without a flash. Disregarding the level of illumination in both images, notice the tiny diamond-like reflections along the wing patterns in the bottom image. These specular highlights can sometimes be very pleasing, though they can be distracting. If you don't like specular highlights, then use a diffuser, bounce the flash off an umbrella or through a scrim, use a reflector, or try a fill-flash with white cloth or tissue over the front of the unit.

## Misleading Exposure

A full-frame or center-weighted light reading of a light-colored butterfly in full sunlight can mislead some camera metering systems. The meter is programmed to register more light reflection coming from the subject than there actually is, and tends to underexpose. Dark subjects that absorb more light also can fool the light meter, this time into overexposing the image. The solution is to anticipate the possibility of error and take corrective action. Take a careful light reading off a gray card and bracket up or down slightly, depending upon the color of the butterfly. This requires that the camera's settings be set to manual.

*Above: A Gulf Fritillary (Agraulis vanillae) photographed with natural light (top), and with a flash (bottom). Natural lighting reveals leaves in the background, and is slightly underexposed. The photo was taken with a flash, and shows a black background. Note the tiny reflections, or specular highlights, along the black lines in the center of the wings.*

*Opposite: This Spicebush Swallowtail (Papilio troilus) is dark, so to see its features, allow a little more light to strike the film plane. This requires a subtle change in the f-stop (e.g., go from f11 to f10 or f9).*

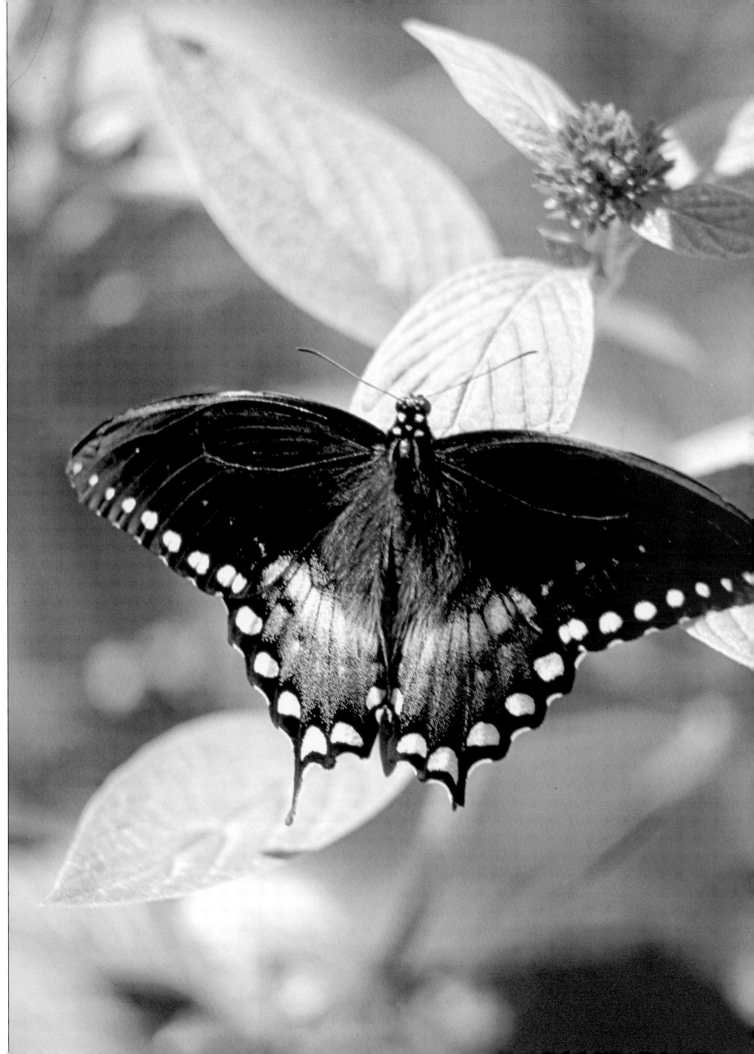

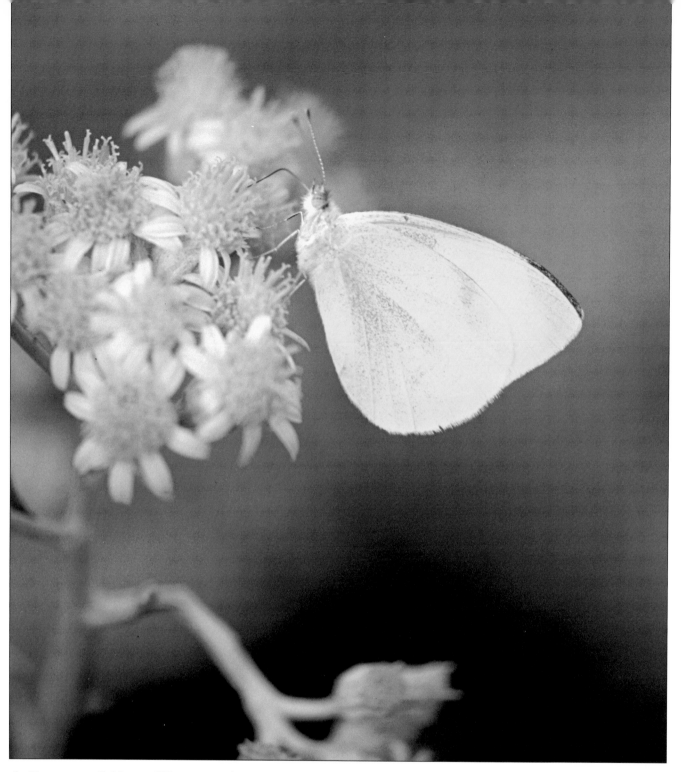

*A European Cabbage White (Artogeia rapae) photographed sideways, allowing the entire butterfly to appear in focus.*

## ☐ The Problem of a Narrow Depth-of-Field

When working with a tiny subject at very close range, the depth-of-field becomes very narrow. If one chooses to focus on the eyes in order to give "life" to the image, there will be a gradual loss of sharpness extending from the eyes out towards the ends of the wings. There are several solutions to this problem.

• You can use a higher ISO rated film, which permits a smaller aperture (e.g. from f11 to f16), and helps to produce greater depth-of-field.

• You can wait until the butterfly is on a horizontal plane and photograph it sideways.

• You can photograph the butter-

fly looking straight down, with its wings spread out against the ground.

- You can place the camera on a tripod and work with a slower shutter speed (and higher f-stop).

- You can switch to a different lens (e.g. a 105mm macro in stead of a 200mm lens with two extenders). Remain flexible, especially if the butterfly allows a close approach. One macro lens without an extender allows much better depth-of-field than a more powerful lens with an extender or multiplier.

- You can use a flash, fill-flash, or reflector.

When working up close with butterflies, it's difficult to have everything in sharp focus. These and other obstacles to good butterfly photography, in a curious way, make it rewarding. When everything works together and a beautiful image is produced, the fulfillment is worth the effort.

*An Asian Buckeye (Precis species) was sitting on the ground warming itself. It is completely in focus.*

# Favorite Images 7

The goal of every photographer is to share his or her images with others.

This closing portion of the book gives me the chance to do just that and to add a few personal observations about each image. Also included is technical information (such as the camera settings used, the lens selected for the shot, as well the film speed and any accessories used). Also covered are topics such as lighting and composition. All in all, this section will help you tie together the diverse elements of butterfly photography discussed in the previous chapters.

My hope is that you will join the thousands of other photographers in capturing the beauty of these butterflies.

## *PARADE OF BUTTERFLIES*

*In my mind's eye*
*I see a parade of Butterflies*
*Flying through the sky.*

*Led by the Monarch and his Queen,*
*Both in golden raiment royal seen.*

*The Crown Prince iridescent,*
*A perfect rainbow's evanescence.*

*Dukes of sabled vestment cloaks,*
*The gold edges of their power spoke.*

*The Earls and Squires*
*In formal tails did awe inspire.*

*The Admirals and Viceroys did their presence make*
*Striped in formal rank lest no one them mistake.*

*Diana and Aphrodite with nymphs and elfins*
*Next passed by me.*

*Courtiers, dazzling and bright,*
*Followed by dancers in pastel lights.*
*Amid which Emeralds and Peacocks completed the sight.*
*And a gypsy lad bade good-bye to the night.*

*The parade passed by*
*And, I thought, what a dream had I.*

Plate 1

## American Lady

*(Vanessa virginiensis)*

This lovely butterfly, also known as the "Hunter's Butterfly" or the "Virginia Lady," is one I have photographed many times. This "Lady" was photographed in Meadowlark Gardens, Vienna, Virginia, which features an herb garden that is a magnet to butterflies. Here the Lady was feeding on May Night hybrid sage (*Salvia superba "mainacht"*). The American Painted Lady is a brush-footed butterfly that frequents gardens.

This is an instance where the butterfly is not the central part of the photograph. Instead, it's part of the photograph of sage. The photograph was taken in bright sunlight; note the heavy shadows.

|  |  |
|---|---|
| Camera: | Nikon FM2 |
| Lens: | 80-200mm |
| Shutter speed: | 1/125 |
| Aperture: | f8 (bracketed to f7) |
| Polarizer: | Yes |
| Flash: | No |
| Film: | ISO-100 |
| Tripod: | No |
| Hand-held: | Yes |

Plate 2

## Spring (Summer) Azure

*(Celastrina neglecta)*

The Spring (Summer) Azure is part of the Gossamer Wing group of butterflies. It's a small butterfly found in open woods, roads, clearings, and in mountains throughout North America and is one of the first butterflies to appear in spring (thus its name). Host plants include dogwoods, viburnum, blueberries, black snakeroot, and meadowsweets. This Azure was feeding on mountain mint (*Pycanthemem muticum*).

Although this is not a close-up, the 80-200mm zoom lens provides

*Plate 1*

incredibly detailed images. Note the thread-thin proboscis and the fact that the subject is not in the center of the page. The rule of thirds was used to place it near the top left side of the picture.

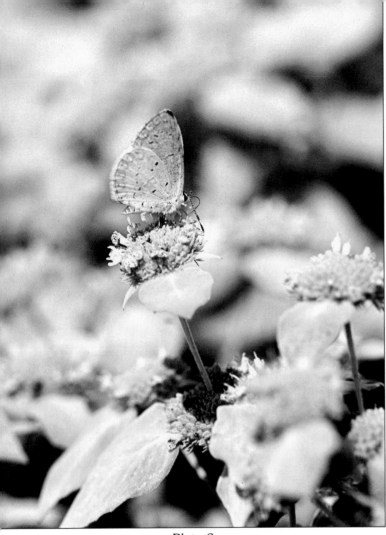

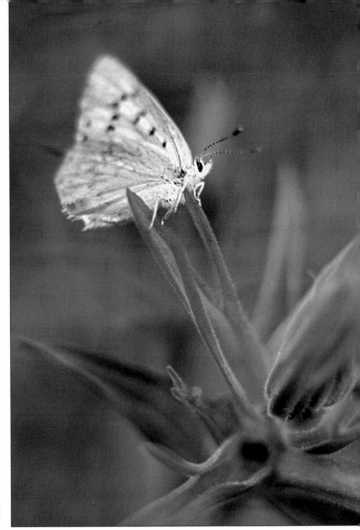

*Plate 2*

*Plate 3*

Camera: Nikon FM2
Lens: 80-200mm
Shutter speed: 1/125
Aperture: f8 (bracketed to f10)
Polarizer: Yes
Flash: No
Film: ISO-100
Tripod: No
Hand-held: Yes

Plate 3
## Lilac-Bordered Copper
*(Lycaena epidemia nivalis)*
The Lilac-bordered Copper is classified as part of the Gossamer Wings family, and lives in mountains amid flowered slopes and meadows and in forest clearings. The butterfly's range extends from British Columbia to California and eastwards to Wyoming and Colorado.

This was the first photograph of a butterfly I ever took. Dr. Robert Michael Pyle, the guest lecturer on butterflies and natural history for the National Wildlife Federation Conservation Summit in Snowbird, Utah, found this butterfly in an alpine meadow resting on an Indian Paintbrush. All class members had a chance to photograph it. I can't say who was more curious, the butterfly or the students, for it stayed in place until we moved on. It was this one butterfly encounter that resulted in my enduring fascination with butterflies.

Camera: Nikon FM2
Lens: 55mm macro
Shutter speed: 1/60
Aperture: f16
Polarizer: No
Flash: No
Film: ISO-64
Tripod: No
Hand-held: Yes

Plate 4

## Ruddy Daggerwing
*(Marpesia petreus)*

A brush-footed butterfly found mostly in eastern Texas and in southern Florida, the Ruddy Daggerwing is especially common in Florida's Everglades National Park. The caterpillars feed on fig leaves, while the mature butterflies feed on ripe figs, fruits, and milkweed.

This image was taken in Florida using available light in slightly overcast conditions. Shadows are nonexistent and the depth of field is minimal because the poor illumination required a low aperture setting. The butterfly, however, is in proper focus.

|  |  |
|---|---|
| Camera: | Nikon FM2 |
| Lens: | 80-200mm |
| Shutter speed: | 1/125 |
| Aperture: | f5.6 to f4 |
| Polarizer: | No |
| Flash: | No |
| Film: | ISO-100 |
| Tripod: | No |
| Hand-held: | Yes |

Plate 5

## Gulf Fritillary
*(Agraulis vanillae)*

A brush-footed butterfly, the Gulf Fritillary is found all around the Gulf of Mexico region where warm weather keeps it happy. This beautiful creature breeds from California to Florida, occasionally straying as far north as the Great Lakes and the Mid-Atlantic states. This is only temporary, however, since it can't withstand winter weather. Host plants include passionflowers and many other species, and it's one of the species that will visit city gardens.

This image is unusually crisp thanks to full bright sunlight (notice the strong shadows) which allowed the

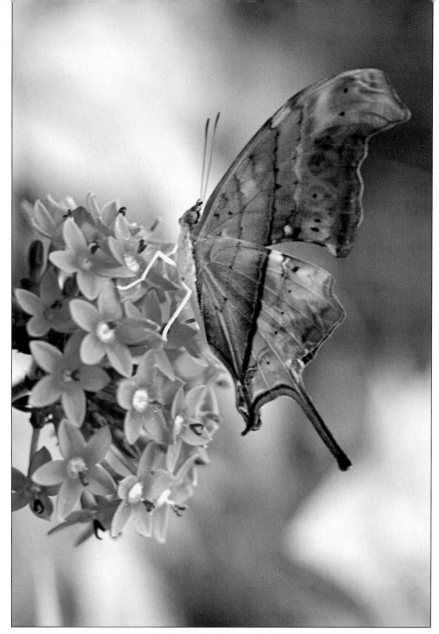

*Plate 4 (above), Plate 5 (below)*

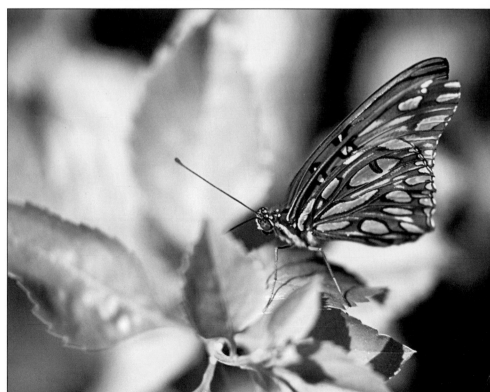

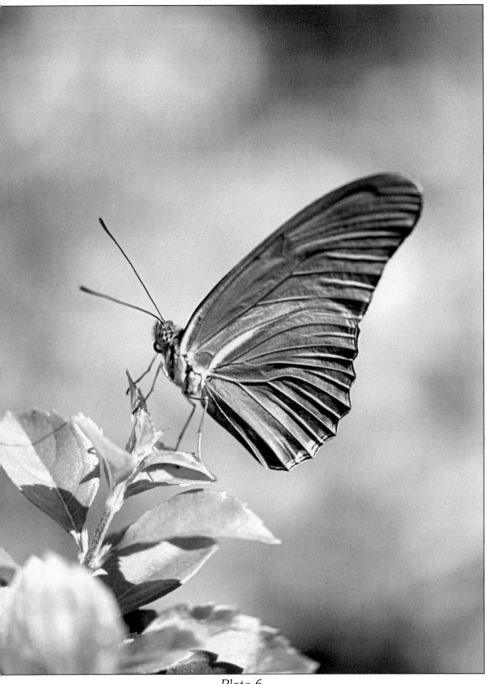

*Plate 6*

Plate 6
## Julia
*(Dryas iulia)*
What a magnificent butterfly! A wonderful orange highlights this brush-footed butterfly which is found in Southern Texas and Florida. It lives in hammocks and gardens as well as tropical islands in the Caribbean and is quite abundant in the Florida Keys. The caterpillars feed on passionflower vines, which are believed to make the species distasteful to birds.

This stunning specimen was photographed in full sunlight at around noon. Note the straight up-down shadows. The photography is so crisp that a bit of "peach fuzz" (labial palp) just over the proboscis can be seen. That is fine detail!

Camera: Nikon FM2
Lens: 80-200mm
Shutter speed: 1/125
Aperture: f8 (bracketed to f6)
Polarizer: Yes
Flash: No
Film: ISO-50
Tripod: No
Hand-held: Yes

Plate 7
## Malachite
*(Siproeta stelenes)*
As beautiful as the rock it is named after, this brush-foot is found in southern Florida and southern Texas and throughout the year in the Tropics.

This individual was photographed in a butterfly farm shortly after it emerged as an adult. Heavy clouds overhead reduced the illumination (no shadows), requiring a careful reading of light conditions. The horizontal position of the butterfly kept the entire butterfly in focus.

camera to be set at 1/125th of a second at f16.

Camera: Nikon FM2
Lens: 80-200mm
Shutter speed: 1/125
Aperture: f16
Polarizer: No
Flash: No
Film: ISO-100
Tripod: No
Hand-held: Yes

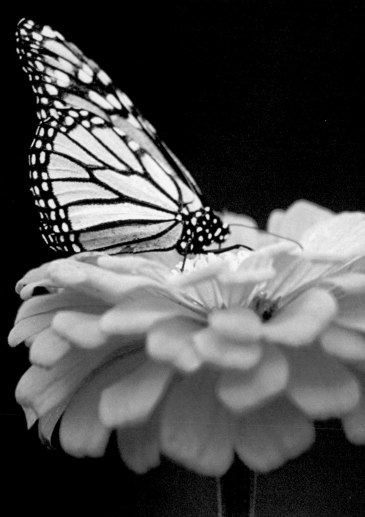

Plate 7

Plate 8

Camera: Nikon FM2
Lens: 80-200mm
Shutter speed: 1/125
Aperture: f5.4 to f4
Polarizer: No
Flash: No
Film: ISO-100
Tripod: No
Hand-held: Yes

Plate 8

## Monarch

*(Danaus plexippus)*

The Monarch is one of three milkweed butterflies found in North America. It's a powerful flyer, migrating to overwintering areas in California and Mexico and found almost throughout North America. Organizations in both Mexico and the United States have begun programs to protect the millions of Monarchs that return to Mexico each winter, but the species is still threatened by loss of these winter habitats because of illegal logging and other development. Attract Monarchs to your garden by planting butterflybush, zinnias, and Mexican sunflower.

This specimen was photographed using a 600mm lens with an extender that allowed maximum approach to the flower. The depth of field for an image this close is extremely tight. Since this was a very heavy lens, it was placed it on a tripod, which allowed the shutter speed to be reduced 1/30th of a second and permitted an aperture setting of f16 for use with the ISO-100 speed film. This setting was required by the use of the extender. This procedure would have been impossible without a tripod. Flash was not used.

Camera: Nikon FM2
Lens: 600mm
Shutter speed: 1/30
Aperture: f16
Polarizer: No
Flash: No
Film: ISO-100
Tripod: Yes
Hand-held: No

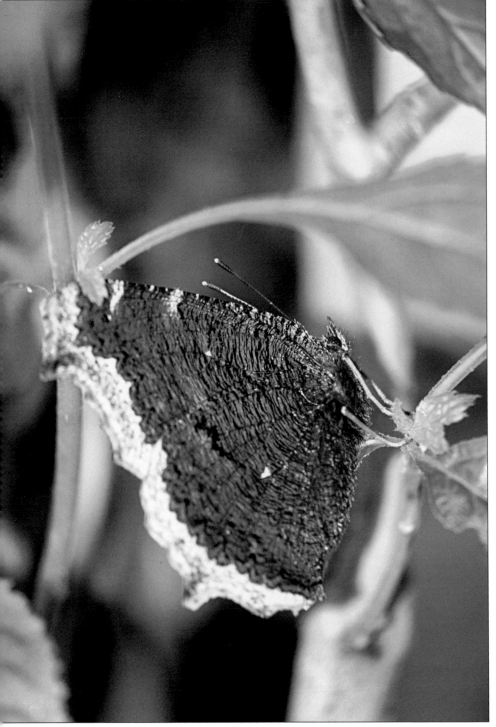

*Plate 9*

Plate 9
## Mourning Cloak
*(Nymphalis antiopa)*
The Mourning Cloak is another member of the brush-footed family. This butterfly is a master of camouflage, fading into near invisibility against brown bark when it is at rest. If approached by a bird or other predator, it will instantly fly away, startling the predator with its bright upperside color.

This specimen was photographed using an 80-200mm lens with a flash. The butterfly remained still and allowed several photographs without moving. Bracketing was used despite through-the-lens metering by the camera in flash mode. Most of the images were slightly overexposed because of the dark color of the butterfly. However, bracketing did result in a couple of good photographs. The eye is in focus, but the edge of the wing is not.

Camera: Nikon FM2
Lens: 80-200mm
Shutter speed: 1/250
Aperture: (TTL)
Polarizer: No
Flash: Yes
Film: ISO-100
Tripod: No
Hand-held: Yes

Plate 10
## Queen
*(Danaus gilippus)*
This is one of the "wow" images that make butterfly photography so rewarding. This is another milkweed butterfly that lives on blunt-leafed milkweed, rambling milkweed, and others. This species is found from California to Florida, mostly in the southern states, for it cannot withstand cold winters.

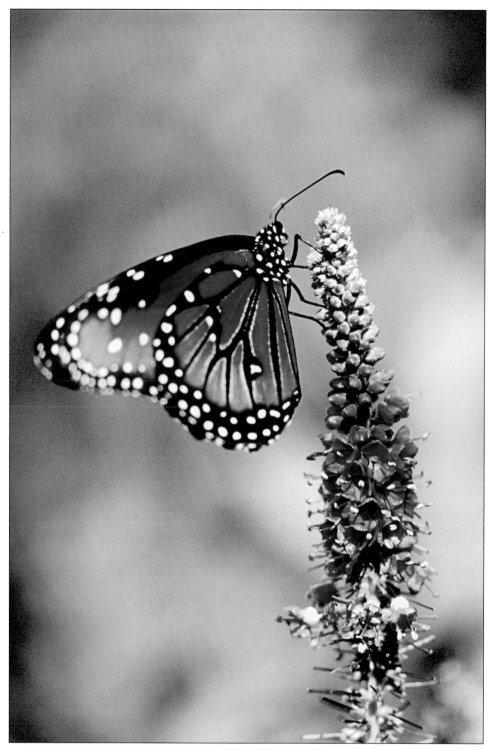

*Plate 10*

I photographed this butterfly feeding in a formal garden. As usual, I used an 80-200mm zoom lens without a flash. The richly saturated colors shows that I used a polarizer.

Camera: Nikon FM2
Lens: 80-200mm
Shutter speed: 1/125

Aperture: f8 (bracketed to f11)
Polarizer: Yes
Flash: No
Film: ISO-100
Tripod: No
Hand-held: Yes

# Appendices

## ☐ Helpful Contacts

### The Lepidopterists' Society

Natural History Museum of Los Angeles County
900 Exposition Boulevard
Los Angeles, CA 90007-4057
Tel: 213-763-3364
Fax: 213-746-2999
*Open to anyone interested in butterflies. Annual dues: $45.*

### National Wildflower Research Center

4801 La Crosse Avenue
Austin, TX 78739
Tel: 512-292-4100
Fax: 512-292-4627
Email: wildflower@onr.com
*A national center for information on wildflowers. Many publications on where, when and how to plant wildflowers.*

### National Wildlife Federation

8925 Leesburg Pike
Vienna, VA 22184-0001
Tel: 1-800-245-5484
Fax: 703-790-4468
Email: carrn@nwf.org
*The National Wildlife Federation recently sold its property and will seek a new site for their headquarters in the next few years. Check for new address information. A great source of information for adults and children interested in nature (especially their Conservation Summits) as well as a source of information for creating a Backyard Wildlife Habitat™.*

### North American Butterfly Association (NABA)

4 Delaware Road
Morristown, NJ 07960
201-285-0907
Web site: www.naba.org
*The North American Butterfly Association is a group of butterfly enthusiasts who wish to cooperate in understanding and saving butterflies. Annual dues: $25.*

### North American Nature Photography Association (NANPA)

10200 West 44th Avenue
Suite 304
Wheat Ridge, Colorado 80033-2840
Tel: 303-422-8527
Web site: http://www.nanpa.org
E-mail: NANPA@resourcenter.com
*NANPA is an organization representing photographers interested in wildlife, wildlife conservation, photographic ethics, and otherwise promoting wildlife photography.*

### The Xerces Society

*4828 S.E. Hawthorne Blvd.
Portland, OR 97215
Tel: 503-232-6639
Fax: 503-233-6794
Web site: www.xerces.org*

Email: xerces@teleport.com
*A great source of information on invertebrate conservation. Annual dues: $25*

## ☐ Commercial Sources of Supplies for Butterflies:

*(No endorsement of any supplier is given or implied)*

### Butterfly Encounters

P.O. Box 604
Danville, CA 94526
Tel: 925-820-4307
Web site:http://www.butterflyfarm.com
*This company sells milkweed seeds and provides maps showing the native range of different milkweeds.*

### Magical Beginnings Butterfly Farms

114 Royce Street, Suite H.
Lost Gatos, CA 95030
Tel: 408-395-5123
*Magical Beginnings also works with the Monarch Butterfly Sanctuary Foundation. You might want to contact them if you enjoy monarchs or are interested in preserving the monarch over-wintering sites in California or Mexico.*

## ☐ Butterfly Farms or Exhibits:

*(No endorsement is given or implied)*

### Butterflies in Flight

6151 A. Everett Street
Naples, Florida 34112
Office: 941-263-6895
Farm number: 941-793-2359
*"Butterflies in Flight" is a butterfly farm located just south of Naples, Florida. For a modest fee, visitors can see a variety of butterflies being raised and learn about host plants. Call ahead for directions and visiting hours.*

### Butterfly Place

Welk Resort Center
2400 State Highway 165
Branson, Missouri 65616
Tel: 417-332-2231
Website: www.butterflyplace.com
*"Butterfly Place" is a live butterfly exhibit in the "Live Entertainment Capitol of the World." Approximately 50 different varieties of butterflies are*

*available. Over 1,500 individual butterflies are normally free flying. For serious photographers, tickets are available which permit tripods to be used from 7:30 A.M. to 9:30 A.M. daily, but reservations are required. Otherwise, tripods are not permitted.*

### Butterfly World

3600 West Sample Road
Coconut Creek, FL 33073
Tel: 954-977-4400
Website: HYPERLINK
http://www.butterflyworld.com
www.butterflyworld.com
*The first butterfly aviary built in the United States just ten miles north of Fort Lauderdale, Florida. Open seven days a week.*

## ☐ Using the Web

The World Wide Web is proving to be a very helpful tool for learning about butterflies. Many photographers put their best photographs on the web for visitors (web "surfers") to see. Depending on the "search engine" selected, one can receive "hits" on thousands of different sites with the word "butterfly" or "butterflies" in their listings. When researching this book, the author typed "butterflies" on the Alta Vista search engine and came up with over 182,000 "hits." When the Infoseek search engine was used, 145,800 sites with the word "butterfly" were shown. It takes a lot of searching to separate the useful sites from the less helpful. When searching vary the words used: lepidoptera or butterfly +photography or butterflies +photography or photographing butterflies or butterfly photography. Try several variations, and the results will be different.

When visiting some of the web sites listed below, it is necessary to type in exactly what is shown. A missing period or "/" may generate a "404 error message" (can't find the site). In that case, try deleting a tiny portion of the address and try again. If that fails, clip off a few more letters, section by section (usually divided by "/") until the site opens. Then follow the instructions given in the site. If you want to revisit a site, bookmark it.

## ☐ Interesting Butterfly Sites

Before starting your search, please understand that web-sites come and go. What appears one year may not be around the next. Don't be disappointed if the sites shown below can't be found following publication of this book. Instead, simply "search" for new sites.

### The U.S. Geological Survey

The U.S. Geological Survey provides one of the most comprehensive database of butterflies found on the web. It can help identify or locate butterflies down to county levels in your state. For this great resource type: www.npwrc.usgs.gov/resource/distr/lepid/bflyusa.htm.

This site offers readers a valuable database on butterflies. Once accessed, select Biological Resources, North America, Butterflies of North America, and County Checklists. This will take you to the section providing information about butterflies on the county level for the various U.S. states. The site also provides a menu that allows individual research into a specific butterfly, including photographs and a description of the habitat, life cycle, and other information associated with that species. This can really assist the photographic novice and established professional photographer alike.

### www.butterflywebsite.com

www.butterflywebsite.com also helps visitors obtain information about butterflies. Hopefully these organizations will be around long after this book is published and their information will remain fresh and current.

### Butterfly World

Butterfly conservatories from Austria to Wales can be found by contacting: www.ifbe.org. This is the home page of "Butterfly World" in Florida, and they can provide not only information about their own facility, but they also provide a current listing of butterfly sites all over the globe.

### The Lepidopterists' Society

The Lepidopterists' Society web site is: www.furman.edu/~snyder/snyder/lep/index.html. The Lepidopterists' Society is more scientific in its orientation, but does welcome new members.

### Web Sites from Around the World

www.chebucto.ns.ca/Environment/NHR/lepidoptera.html gives visitors access to a listing of web sites from around the world arranged alphabetically. If one were looking for a local butterfly group, this would be a good place to begin a search. The site is in Nova Scotia, Canada. If the site cannot be accessed as shown above, type in: www.chebucto.ns.ca. Choose Science, Environment and Technology, and then The Environment. Look for "Our Community" and choose Natural History Resources. The final selection is Lepidoptera.

### The Smithsonian Institution

The Smithsonian Institution operates a butterfly web-site, which is also a useful site to visit: http://web3.si.edu/resource/tours/gardens/butterfly/facts.html.

### The National Academy of Natural Sciences

The National Academy of Natural Sciences in Philadelphia, Pennsylvania also has an interesting web-page: www.acnatsci.org.

### The National Wildlife Federation

The National Wildlife Federation web site is: www.nwf.org. It has information about its many conservation programs and educational programs. It describes its publications, including magazines for children, and provides information on how to build a backyard garden suited for butterflies and birds.

### For Children

A site for children is: www.mesc.usgs.gov/butterfly/Butterfly.html. It is operated by the U.S. Government and offers information that children might enjoy.

## Regional Information

Another helpful guide is www.butter-flies.com/guide.html where information about butterflies on a regional basis is available.

## Feeders, Houses and Books

Individuals wishing to purchase butterfly feeders, houses, or books about butter-flies might find the following site worth visiting: www.birdsforever.com/butter.html.

## Butterfly Gardener

A nice site, operated by an individual butterfly gardener, can be found at www.tconl.com/~mines/. It shows what individuals can do to share their knowledge with interested readers.

## Monarch Watch

Two other interesting sites on Monarchs include "Monarch Watch" at: http://monarchwatch.org/ index.html and "Journey North – A Global Study of Wildlife Migration" at: http://www.learner.org/jnorth/.

## Nature Conservancy

Finally, information about the Nature Conservancy and their world-wide pro-grams to preserve and protect wildlife habitat can be found at: http://www.tnc.org.

The World Wide Web can be a lot of fun. It is possible to find "Butterflies of Israel" or Malaysia or Belize. You can arrange for a trip to a butterfly ranch in Costa Rica or buy butterfly books right off the net. There are hundreds of sites with information about butterfly garden-ing with tips on just the right plant for a specific region of the United States or Canada. Remember to "bookmark" the best sites and you'll have them quickly available when planning a trip or when you need information about a particular species of butterfly.

A very fine source of information for photographs or butterflies from all over the world can be located at the Alta Vista search engine home page. Up near the top of the screen, Alta Vista allows the viewer to select: Specialty

Searches. The next menu offers: AV Photo Finder. The viewer must then type in butterflies. The results are quite spectacular and demonstrate the level of photography that readers of this book should be able to produce with all the tips.

## ☐ Commercial Sources of Equipment or Supplies for Photographers

*(No endorsement of any product, com-pany, manufacturer, supplier is given or implied. This is not a complete list-ing and omission of any company or product does not constitute nor imply any negative connotation. For current information about other products please contact your photo dealer or search the web)*

## Products

Avery produces Laser Labels that fit on the wide edge of slide mounts. They come in packages (#5267) consisting of 80 labels per sheet (each 2" by 1-3/4"). Word processing programs produce individual labels that can be fed through a laser printer. The labels peel off and can be stuck to slide mounts. Contact an office supply store for supplies.

Bardes Products, Inc. in Milwaukee, Wisconsin provides a large variety of photographic vinyl products for storing photographs. Call: 1-800-223-1357 or fax: 414-354-1921.

BRIGHTSCREEN at 1905 Beech Cove Drive, Cleveland, TN 37312 (1-800-235-2451) produces grid screens that are brighter than original screens. The process makes it much easier to see butterflies in low light conditions. Consult with you camera dealer to determine whether or not a Brightscreen will affect your camera's automatic light readings.

Stephen Fossler Company in Crystal Lake, Illinois (1-800-762-0030) pro-duces labels that can be used on framed pictures.

Paper Direct (1-800-A-PAPERS) offers a variety of paper products for new businesses.

## Web Sites for Camera Equipment
- Hasselblad
www.hasselblad.com
- Mamiya
www.mamiya.com
- Minolta
www.minolta.com
- Nikon
www.nikon.com
- Olympus
www.olympus.com
- Pentax
www.pentax.com
- Sigma
www.sigmaphoto.com
- Voigtlander
www.thkphoto.com

## Lenses
- Tamron
www.tamron.com
- Schneider Optics
www.schneideroptics.com

## Tripods
- Bogan
www.bogan.com
- Slik
www.tocad.com

## Film
- Fuji
www.fujifilm.com
- Ilford
www.ilford.com
- Kodak
www.kodak.com

## Straps
www.optechusa.com

## Light Meters
www.sekonic.com

## Bags
www.lowepro.com
www.tamrac.com

## ☐ Magazines
*Outdoor Photographer*
www.outdoorphotographer.com

## ☐ Recommended Books
### Butterflies:
*Butterfly Gardening – Creating Summer Magic in Your Garden* (Xerces Society/Smithsonian Institution, Sierra Club Books in Association with the National Wildlife Federation, South Sea International Press, Ltd. Hong Kong, 1990 and the revised edition, 1998). This book used one of my images of a golden skipper in the 1990 edition and cabbage whites in the 1998 edition.

*Garden Butterflies of North America - A Gallery of Garden Butterflies & How to Attract Them*, by Rick Mikula. (Willow Creek Press, Minocqua, WI, 1997).

National Audubon Society Field Guide series. The National Audubon Society has field guides for many subjects. A useful series is the set devoted to individual states. *The Field Guide to Florida*, for example, has a much more limited section on butterflies, which makes them easier to find. The book includes local flower and fauna, parks and preserves, and maps. It's quite a helpful series. (A Chanticleer Press Edition published by Alfred A. Knopf, New York, 1998).

*Peterson Field Guides, Eastern Butterflies*, by Paul A. Opler and Vichai Malikul. (Houghton Mifflin Company, Boston and New York, 1998). An excellent guide to butterflies of the eastern portion of North America. Carefully illustrated with both drawings and photographs. The work helps reduce the total number of butterflies to 525 species, ranging from Mexico north to Greenland.

*The Audubon Society Field Guide to North American Butterflies*, by Robert Michael Pyle. (A Chanticleer Press Edition, Alfred A. Knopf, New York, 1998 (fourth publishing)). One of the best publications on butterflies in North America.

*Handbook for Butterfly Watchers*, by Robert Michael Pyle. (Houghton Mifflin Company, Boston, New York, and London, 1984).

*Butterflies – How to Identify and Attract them to your Garden*, by Marcus Schneck. (Rodale Press, Emmaus, PA, 1990). This is a guide to 250 of the most popular butterflies in North America.

*The Butterfly Book - An Easy Guide to Butterfly Gardening, Identification, and Behavior*, by Donald and Lillian Stokes and Ernest Williams. (Little, Brown and Company, Boston, New York, Toronto, London, 1991).

### Nature Photography:
*Caught in Motion - High-Speed Nature Photography*, by Stephen Dalton. (Van Nostrand Reinhold Company, New York, 1982).

*The Art of Photographing Nature*, by Martha Hill and Art Wolfe. (Crown Trade Paperbacks, New York, 1993).

*Designing Wildlife Photographs – Professional Field Techniques for Composing Great Pictures*, by Joe McDonald. (AMPHOTO, American Photographic Book Publishing, an imprint of Watson-Guptill Publications, New York, 1994).

*The Complete Guide to Wildlife Photography - How to get Close and Capture Animals on Film*, by Joe McDonald. (AMPHOTO, American Photographic Book Publishing, an Imprint of Watson-Guptill Publications, New York, 1992).

*The Nature Photographer's Complete Guide to Professional Field Techniques*, by John Shaw. (AMPHOTO, American Photographic Book Publishing, an Imprint of Watson-Guptill Publications, New York, 1984).

*Closeups in Nature - The Photographer's Guide to Techniques in the Field*, by John Shaw. (AMPHOTO, American Photographic Book Publishing, an Imprint of Watson-Guptill Publications, New York, 1987).

*The Professional Photographer's Guide to Shooting & Selling Nature and Wildlife Photos*, by Jim Zuckerman. (Writer's Digest Books, Cincinnati, Ohio, 1991).

### General Photography:
*Basic 35mm Photo Guide for Beginning Photographers*, by Craig Alesse. (Amherst Media, Inc., Revised edition, Buffalo, New York, 1998).

*Light – Working with Available and Photographic Lighting.* by Michael Freeman. (The Amphoto Photography Workshop Series, Watson Guptill Publications, New York, NY 1988).

*The Photographer's Guide to Exposure – Illustrated Techniques for Using your Equipment Effectively and Creatively*, by Jack Neubart. (AMPHOTO, American Photographic Book Publishing, an Imprint of Watson-Guptill Publications, New York, 1988).

## ☐ Butterfly Conservation
Increasing loss of habitat is having a gradual impact on populations of butterflies. Readers who want to attract butterflies to a backyard, neighborhood, park, county, or state, should consider plantings that attract and maintain butterfly populations and, possibly most importantly, should do all they can to support habitat conservation efforts. The first North American butterfly species that became extinct because of man's doing was the Xerces Blue butterfly (Glaucopsyche xerces). The Xerces Blue butterfly died out when its coastal habitat was destroyed by construction in 1943. This resulted in the establishment of The Xerces Society that is dedicated to protecting butterfly habitat. The Nature Conservancy is another group committed to preserving wildlife habitat.

### Cultivate Host Plants
• For Butterfly Eggs
One cannot plant some pretty flowers and expect to develop a resident population of butterflies. A lovely rose garden simply won't attract a population of butterflies because roses produce no nectar. Although they need flowers for their nectar, butterflies also need specific host

*These tiny specks are the eggs laid by the Asian Monarch (Danaus chrysippus) on the pod of a milkweed, a common weed that is a vital host to Monarchs.*

plants to lay their eggs on. If they cannot find plants to serve as hosts for their eggs, they fly elsewhere for egg laying. When buying plants, consider this important part of their life cycle. For example, milk vetch, parsley, passionflower, plantain, sorrel, violets are all important sources of larval food plants.

• For Caterpillars

Unfortunately, butterfly eggs turn into caterpillars, and caterpillars have voracious appetites. Consider assigning a portion of the backyard to plantings of those host plants needed by caterpillars. Some of the most important sources of food include milkweed and other common weeds that are increasingly being uprooted to build new communities, shopping malls, and parking lots. These weeds are host for some of America's most beautiful butterflies, including the monarch and queen butterflies. Few lament the loss of weeds, but all of us will be poorer for the butterflies that no longer appear in our gardens. Perhaps there is room in the neighborhood for a few milkweeds, grasses or plants. The National Wildlife Federation has information about designing a Backyard Wildlife Habitat™, as do many of the

butterfly books and websites listed in the appendix section.

A word of caution. Some butterflies feed on toxic plants because it makes them noxious or foul tasting to birds. Milkweeds fall into this category. Thistles and stinging nettles are not toxic, but may not be considered desirable in a formal garden. However, without milkweeds there will be few Monarchs; without thistles there will be no Painted Ladies, and without stinging nettles there will be no Red Admirals. If these species are desired, then a small portion of the garden should be devoted to these "weeds." State agricultural services or wildlife offices might be able to provide more information about "weeds" that can be planted to support local species of butterflies.

*Caterpillars of the American Painted Lady (Vanessa cardui or V. virginieensis) grow quickly before their transformation into chrysalides and thence into adult butterflies.*

• For Local Species

Generally, planting flowers, bushes, herbs, grasses, or weeds that don't serve as hosts to local species of butterflies is not very productive. There are exceptions; popular nectar plants in gardens (such as the butterfly bush), which are "alien," draw in and nourish a lot of butterfly species. Although some butterflies, such as the spectacular Monarch, can be found in large areas of North America, others are found only in a few

places where native plants species alone assure their survival. This is especially true for those butterfly species confined to a particular larval host plant. When the butterfly is not known to fly far from its host plant, then that species could benefit from an effort to replant specific host plants. Building new sites (near to older sites or in the typical butterfly habitat) *is* a constructive venture. Members of the Washington Metropolitan Area Butterfly Club are planting Turtlehead, for example, in an effort to rebuilt the population of the Baltimore Checkerspot (*Euphydryas phaeton*), Maryland's official state butterfly. Turtlehead is a favorite of Maryland's deer population, and the growing herds are eating the Baltimore Checkerspot's vital host plant.

Is there a similar project that a local gardening club, 4-H club, Scout group, or butterfly club might undertake? Hometown newspapers might appreciate some high quality images of threatened butterflies and who knows what some dramatic photographs might be able to foster. Grass roots organizations are helping to restore bluebirds to America, and similar efforts to preserve native habitats might help butterflies.

### Cultivate a Conservation Ethic

Not all of us can, nor want, to go out and buy weeds or unattractive plants for caterpillars to devour. Certain communities or developments may have restrictions preventing that practice. Public officials might also take a dim view of someone planting stinging weeds or other nuisance weeds. If that's the case, then efforts to preserve existing habitats might be more beneficial.

Nobody should collect butterflies and then place them into a refrigerator to chill them or use chemicals to dull their senses in order to take a picture. It not only produces an unnatural look, but also is ethically questionable. Netting and pinning butterflies does contribute to the understanding of butterflies. However, it is more challenging and rewarding to photograph living butterflies in their natural habitat – without

stressing or harming these graceful creatures. If you ever hope to be a published photographer, butterflies with pins holding them in place simply will not sell, unless that is specifically requested by the editor.

### ☐ Frequently Used Terms

**APERTURE:** The settings on a lens that control the amount of light that pass through the lens. Aperture settings are called f-stops, and, depending on the lens, typically include f2, f2.8, f3.5, f4, f4.5, f5.6, f8, f11, f16, f22, f32 and f62. The areas between marked aperture settings (e.g., f6, f7 or f12, f13, f14, or f15) can also be selected. Low aperture settings admit more light. Subsequent settings allow less light. Low aperture settings have less depth-of-field, resulting in an out of focus area in front of and behind the subject. Low aperture settings are needed in low light situations. High aperture settings are needed in bright light (bright sun or flash), but produce better depth-of-field.

**ASA:** The film speed number set by the American Standards Association (ASA). Now film speeds are set by the International Standards Organization (ISO). See ISO.

**BLUR:** Blurring normally refers to motion, but in many cases refers to the soft, out-of-focus background produced when using lower aperture settings or a telephoto lens with one or more extenders. A blurred background sometimes helps the subject stand out clearly and is certainly a recommended procedure. A tripod is usually required.

**BLURRING:** Generally caused by low shutter speeds. Camera motion is usually the problem and is caused by hand-holding a camera with a lens that should be placed on a monopod or tripod. To avoid blurring, keep the shutter speed at or above the size of a lens (e.g., 1/250th of a second for an 80-to-200mm zoom lens). Blurring may also be the result of the butterfly moving too fast or fluttering its wings. Unless a blurred effect is desired, the shutter speed should be set to 1/125th or 1/250th of a second.

**BRACKETING:** Deliberate under- or overexposing. Manually adjusting the aperture below or above the recommended setting while keeping the shutter speed constant. This technique is helpful for bright white or yellow butterflies (bracket from f11 to f13, for example) and for dark blue or black butterflies (bracket from f11 to f9). Some cameras feature bracketing modes.

**B (BULB):** One of the shutter speed selections. When used with a cable release, the B setting keeps the shutter open until the cable is released. Good for night photography but not useful for butterfly photography.

**DEPTH-OF-FIELD:** Depth-of-field is the area in front or behind a subject that is in focus. Low aperture settings have minimal depth-of-field, while high aperture settings have better depth-of-field. Depth-of-field is critical to good butterfly photography.

**FILL-FLASH:** Use of flash equipment to illuminate shaded areas. Only a small amount of illumination is usually necessary. Experimentation is needed to determine procedures that will work in the field. Use diffusers that come with the flash or experiment with bouncing flash off reflectors or through white cloth or paper.

**FILM SPEED:** The ISO rating of the film. Lower ISO rated films (e.g., ISO-25, 50, or 64) have better resolution, so images are sharper. Moderate ISO films (ISO-100 to 200) produce great photographs, but the resolution is not as compact as lower rated films. Higher rated ISO films (ISO-400, 800, 1,000 or above) have less resolution and may produce a "grainy" image. All films should be hand-inspected to avoid damage (fogging) while traveling. Never pack film in bags that go in the hold of aircraft, since new security technology will fog all unprocessed film.

**FOCUS:** The portion of a subject that is in focus (see depth-of-field). Low aperture settings have minimal depth-of-field while high aperture settings have better depth-of-field. In butterfly photography, where the subject is tiny, the area in focus – even under the best of circumstances – is narrow. Use of full-flash, fill-flash, reflectors, etc. might be needed to obtain greater depth-of-field.

**F-STOPS:** The settings on a lens that control the amount of light that pass through the lens (see aperture). F-stops typically include f2, f2.8, f3.5, f4, f4.5, f5.6, f8, f11, f16, f22, f32 and f64 depending upon the lens. The areas between marked f-stops (e.g., f6, f7, f9, f10, f12, f13, f14, f15, f17, f18, f19, f20, or f21) can also be selected. Low f-stops admit more light. Low f-stop settings have less depth-of-field, resulting in an out of focus area in front of and behind the subject. Low f-stop settings are needed in low light situations. Subsequent settings allow less light. Higher f-stops settings are used in bright sunlight or flash, and produce better depth-of-field.

**GRAY CARD:** A piece of cardboard that has been printed to reflect exactly 18-percent gray. When viewed through a camera view-screen, an exact light reading can be taken that will produce good results. It can be used with extenders, multipliers, and polarizers. It works in full sunlight or in the shade. However, the subject must be illuminated by same source of light.

**HIGH SETTINGS:** High (or higher) aperture or shutter speeds usually include those over f11 or shutter speeds over 1/125th of a second. These are possible on bright days with minimal clouds and no attachments. Higher settings may be allowed with flash, fill-flash, or reflectors. Best used with more powerful lenses (e.g., those over 100mm).

**ISO:** The film speed number set by the International Standards Organization (ISO). Previously known as ASA after the American Standards Association.

**LOW SETTINGS:** Low (or lower) aperture or shutter speeds generally refer to those under f5.6 or shutter speeds of under 1/60th of a second. These settings are required in very low light situations (dawn or dusk, rainy days, or indoors) or when using low ISO film,

several extenders and/or a multiplier. Generally must be taken with a tripod.

**MEDIUM SETTINGS:** Medium aperture or shutter speeds ordinarily include aperture settings of between f5.6 and f11 and shutter speeds between 1/60th and 1/125th of a second. Usually needed on sunny or partially cloudy days, when a polarizer is used or when an extender or a multiplier is added. If more than one device is used, then settings typically fall into the low settings.

**OPEN UP**: Increase the aperture setting (e.g., go from f8 to f5.6) to admit more light.

**REFLECTANCE:** All objects reflect light. Black or blue butterflies, however, absorb more light and reflect less light. White or yellow butterflies reflect a lot of light. Cameras are generally calibrated at the factory to treat most objects as reflecting 18-percent gray and tend to subtract light from reflective objects (producing an underexposed image), while adding light to a dark object (producing an overexposed image).

**RULE OF SUNNY 16:** The rule that allows photographers to set their aperture to f16 on a bright sunny day and depending on the ISO of the film used, the shutter speed can be selected (e.g., for ISO-400 speed film the shutter speed should be set at 1/500th of a second, ISO-200 speed film at 1/250th, ISO-100 at 1/125th, ISO-50 at 1/60th, and for ISO-25 film the shutter speed should be set to 1/30th of a second). This generally produces good results as long as the sun remains bright and the subject is fully illuminated. Does not work in the early morning or near dusk, with attachments (such as a polarizer), or in the shade.

**RULE OF THIRDS:** A general photographic principle that recommends that the subject sometimes be placed where the horizontal and vertical lines of a tick-tac-toe (#) pattern intersect (e.g., top left, bottom left, top right, or bottom right). Most butterflies are taken in the center of an image, so some variation in placement can produce more interesting compositions. Grid screens can be purchased which reveal grid lines when viewed through the camera's view screen; this helps in placement.

**SATURATED:** A greater intensity of color. Saturation can be increased by use of a polarizer or through the use of saturated films. The results are usually more intense, with richer, more vibrant colors. Highly saturated films work best in full illumination, so fill-flash or reflectors are needed to reduce shadows.

**SHUTTER SPEED:** The speed at which the camera's shutter opens and closes. This controls the amount of light that is recorded on film. Shutter speeds range from several minutes ("B" for bulb setting) to one second to 1/8000th of a second. Low shutter speeds register motion, while high shutter speeds stop motion. Low shutter speeds permit the use of higher f-stops while high shutter speeds require low f-stops.

**STOP OR STEP DOWN:** Decrease the aperture setting (e.g., go from f8 to f11) to admit less light.

# Index

# Other Books from
# Amherst Media, Inc.

## Basic 35mm Photo Guide

*Craig Alesse*

Great for beginning photographers! Designed to teach 35mm basics step-by-step — completely illustrated. Features the latest cameras. Includes: 35mm automatic, semi-automatic cameras, camera handling, *f*-stops, shutter speeds, and more! $12.95 list, 9x8, 112p, 178 photos, order no. 1051.

## Black & White Photography for 35mm

*Richard Mizdal*

A guide to shooting and darkroom techniques! Perfect for beginning or intermediate photographers who wants to improve their skills. Features helpful illustrations and exercises to make every concept clear and easy to follow. $29.95 list, 8½x11, 128p, order no. 1670.

## Infrared Landscape Photography

*Todd Damiano*

Landscapes shot with infrared can become breathtaking and ghostly images. The author analyzes over fifty of his most compelling photographs to teach you the techniques you need to capture landscapes with infrared. $29.95 list, 8½x11, 120p, b&w photos, index, order no. 1636.

## Secrets of Successful Aerial Photography

*Richard Eller*

Learn how to plan for every aspect of a shoot and take the best possible images from the air. Discover how to control camera movement, compensate for environmental conditions and compose outstanding aerial images. $29.95 list, 8½x11, 120p, order no. 1679.

## Telephoto Lens Photography

*Rob Sheppard*

A complete guide for telephoto lenses. Shows you how to take great wildlife photos, portraits, sports and action shots, travel pics, and much more! Features over 100 photographic examples. $17.95 list, 8½x11, 112p, b&w and color photos, index, glossary, appendices, order no. 1606.

## Professional Secrets of Nature Photography

*Judy Holmes*

Improve your nature photography with this must-have book. Covers every aspect of making top-quality images, from selecting the right equipment, to choosing the best subjects, to shooting techniques for professional results every time. $29.95 list, 8½x11, 120p, order no. 1682.

## Essential Skills for Nature Photography

*Cub Kahn*

Learn all the skills you need to capture landscapes, animals, flowers and the entire natural world on film. Includes: selecting equipment, choosing locations, evaluating compositions, filters, and much more! $29.95 list, 8½x11, 128p, order no. 1652.

## Macro and Close-up Photography Handbook

*Stan Sholik*

Learn to get close and capture breathtaking images of small subjects – flowers, stamps, jewelry, insects, etc. Designed with the 35mm shooter in mind, this is a comprehensive manual full of step-by-step techniques. $29.95 list, 8½x11, 120p, order no. 1686.

## Black & White Landscape Photography

*John Collett and David Collett*

Master the art of b&w landscape photography. Includes: selecting equipment (cameras, lenses, filters, etc.) for landscape photography, shooting in the field, using the Zone System, and printing your images for professional results. $29.95 list, 8½x11, 128p, order no. 1654.

## Outdoor and Survival Skills for Nature Photographers

*Ralph LaPlant and Amy Sharpe*

An essential guide for photographing outdoors. Learn all the skills you need to have a safe and productive shoot – from selecting equipment, to finding subjects, to preventing (or dealing with) injury and accidents. $17.95 list, 8½x11, 80p, order no. 1678.

## Practical Manual of Captive Animal Photography

*Michael Havelin*

Learn the environmental and preservational advantages of photographing animals in captivity – as well as how to take dazzling, natural-looking photos of captive subjects (in zoos, preserves, aquariums, etc.). $29.95 list, 8½x11, 120p, order no. 1683.

## Composition Techniques from a Master Photographer

*Ernst Wildi*

In photography, composition can make the difference between dull and dazzling. Master photographer Ernst Wildi teaches you his techniques for evaluating subjects and composing powerful images. $29.95 list, 8½x11, 128p, order no. 1685.

## Freelance Photographer's Handbook

*Cliff & Nancy Hollenbeck*

Whether you want to be a freelance photographer or just improve your current freelance business, this volume is packed with ideas for creating and maintaining a successful freelance business. $29.95 list, 8½x11, 107p, 100 b&w and color photos, index, glossary, order no. 1633.

## Lighting Techniques for Photographers

*Norm Kerr*

This book teaches you to predict the effects of light in the final image. It covers the interplay of light qualities, as well as color compensation and manipulation of light and shadow. $29.95 list, 8½x11, 120p, 150+ color and b&w photos, index, order no. 1564.

## Computer Photography Handbook

*Rob Sheppard*

Learn to make the most of your photographs using computer technology! From creating images with digital cameras, to scanning prints and negatives, to manipulating images, you'll learn all the basics of digital imaging. $29.95 list, 8½x11, 128p, 150+ photos, index, order no. 1560.

## Achieving the Ultimate Image

*Ernst Wildi*

Ernst Wildi teaches the techniques required to take world class, technically flawless photos. Features: exposure, metering, the Zone System, composition, evaluating an image, and more! $29.95 list, 8½x11, 128p, 120 b&w and color photos, index, order no. 1628.

## Build Your Own Home Darkroom

*Lista Duren & Will McDonald*

This classic book teaches you how to build a high quality, inexpensive darkroom in your basement, spare room, or almost anywhere. Includes valuable information on: darkroom design, woodworking, tools, and more! $17.95 list, 8½x11, 160p, order no. 1092.

## Outdoor and Location Portrait Photography

*Jeff Smith*

Learn how to work with natural light, select locations, and make clients look their best. Step-by-step discussions and helpful illustrations teach you the techniques you need to shoot outdoor portraits like a pro! $29.95 list, 8½x11, 128p, b&w and color photos, index, order no. 1632.

## Infrared Photography Handbook

*Laurie White*

Covers black and white infrared photography: focus, lenses, film loading, film speed rating, batch testing, paper stocks, and filters. Black & white photos illustrate how IR film reacts. $29.95 list, 8½x11, 104p, 50 b&w photos, charts & diagrams, order no. 1419.